D0354393

A PASSION FOR

WATER
COLOR

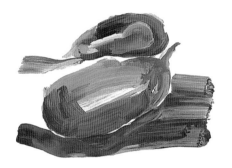

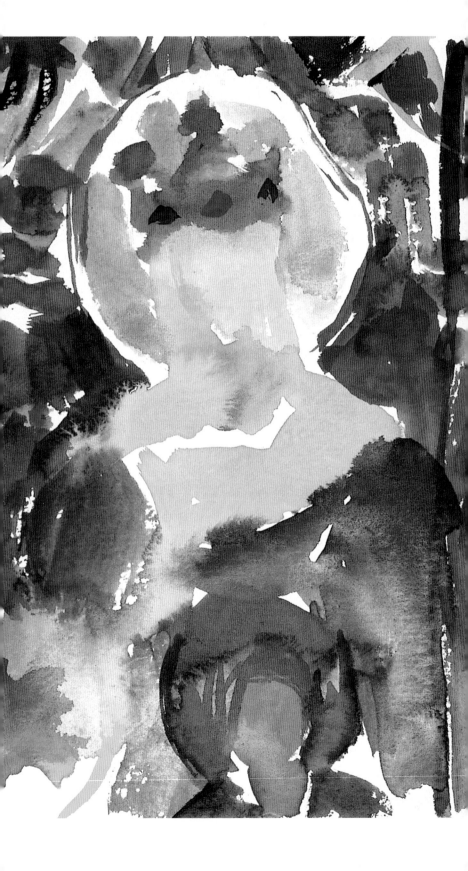

A PASSION FOR

WATER COLOR

PAINTING THE INNER EXPERIENCE

TEXT AND ART BY STEFAN DRAUGHON

WATSON-GUPTILL PUBLICATIONS / NEW YORK

F O R D A V I D

ACKNOWLEDGMENTS

Thank you to those who made this book possible: to all my students and teachers, also to Lewis Falb, Henry Spitz, Sarah Lewis, Marika Krech, Bernard Kirsch, Robin Powell, John Schwartz, Cecile Stolbof, and to so many others. But most especially to Candace Raney, of Watson-Guptill, for her faith in me and my work, for her openness to this book, and for her help in giving it shape. And to my husband, David Hertzberg, without whose love and intelligence this book could never have been.

ABOUT THE AUTHOR

Stefan Draughon holds degrees as Master of Fine Arts in Painting from Parsons School of Design and as Ph.D. in Psychology from New York University. She has taught courses on topics in "Art and Psychology," which she designed and developed, at New York University, the New School, and at the Rhode Island School of Design. Recent solo exhibitions of her paintings and drawings—some of which are reprinted in this book—were at Ceres Gallery and at the Broome Street Gallery in Manhattan's SoHo district.

Senior Acquisitions Editor, Candace Raney
Edited by Robbie Capp
Designed by Areta Buk
Graphic Production by Hector Campbell
Text set in Berling

© 2000 Stefan Draughon

Cataloging-in-Publication Data for this book is available from the Library of Congress.
ISBN 0-8230-0102-4

First printing, 2000
1 2 3 4 5 6 7 8 9 / 08 07 06 05 04 03 02 01 00
Printed in Hong Kong

CONTENTS

PREFACE

I read a preface to find out if a book is for me. This book is for you when you are ready to dig a little deeper into painting in watercolor. Even if you've had some experience painting, have studied with a teacher or from books, you may still want to read "The Basics," but then just scan "Materials and Techniques," and move directly to the heart of my book, "Subjects, Approaches, and the Issues They Raise"—followed by my concluding thoughts.

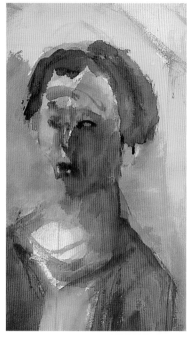

It is scary to find your own path as an artist, rather than follow established guidelines, but the rewards make it worthwhile. At a certain point in my life, I decided to take a chance—to see what I could do with watercolor my own way. Tired of trying to please a teacher, I needed to please myself. When I find my own way—and that path is repeatedly found and

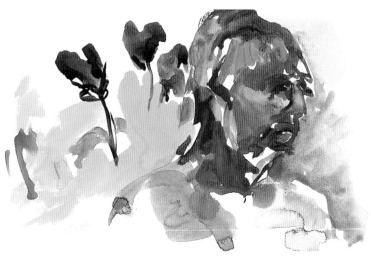

lost and refound again—I feel whole and satisfied with myself, and I see painting as meaningful. Following another's way felt safe and secure; I was part of a group. But I was separated from myself. For me, it has been a perpetual tradeoff between belonging and standing alone.

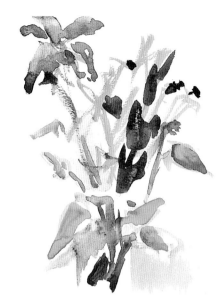

Thoughts of being true to myself make me feel isolated. Yet, I have found that I never feel alone when I like what I'm doing. For me, being cut off from myself and my development as a painter is more painful than being physically or artistically alone. And I've always found like-minded people, new friends, or altered relationships with people I've known for years. It may take a while, and that in-between time can be lonely, but I haven't seen any way to avoid going through those periods of what I call "regrouping," of losing some aspects of myself as I reach for new ones. Without this process of change, I feel less alive and more unsatisfied with my life.

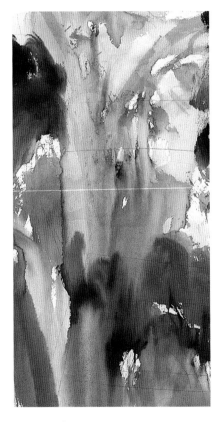

My husband says he married a process. He did. And change can be hard, but staying still feels worse to me. It feels like stagnation, like imitating myself, and that's even scarier for me than change. Change is not for everyone. Is it for you? See what you find.

INTRODUCTION

I walk between art and psychology. Even when I taught topics in psychology or saw a client, I was an artist rather than a scientist—in spite of my background in science. And with time, I've moved farther from that life connected to science toward one that centers on art. I've always emphasized emotion over intellect. But now, I unabashedly seek the pleasure of finding my own path—of "walking on freshly fallen snow."

And watercolor is the perfect medium for my adventure. It, more than any other medium, goes its own way. It drips, forms puddles, is vulnerable to environmental temperature and air currents, to the angle of the working surface, and most especially to every nuance of the touch of my brush, and thus, to my ever-changing feelings. Its color is true and transparent; it reflects each mark—each recorded contact between my medium and the surface to which it is applied. Every stroke leaves an imprint just as each experience in life leaves its impression on us. It is a microcosm of life. Doing watercolor is not therapy, but it has taught me much about the world and about myself.

I didn't think all this out beforehand; not at all. Yet, I knew it, I felt it, and I have never tired of working with watercolor. I certainly never consciously thought: *I consist of 97 percent water* or *The earth is covered in large part with water* or even, *Most life forms are water life—therefore, I should do watercolor.* Not at all. Instead, I thought: *I love the way it moves, the way it looks.* And I still love it now. No question—oil paint gives magnificent color and texture. Yet, I hate the very qualities that permit it to do that: its viscosity and its density. I cannot stand shoving the paint around, having it stay put. I need an interaction between me and fluid watercolor.

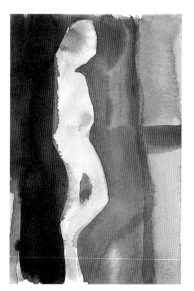

Of course, I don't mind that watercolor is—please forgive the pun—the wave of the future. It avoids solvents with their environmental dangers. It doesn't

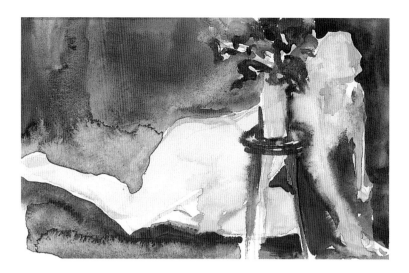

require excessive physical strength, so it can be the medium of choice throughout life, even when we have aches and pains.

But the medium—too often given short-shrift by critics—needs to be trusted and explored. Given its full range of expression, it will receive the devotion it deserves. Watercolor is powerful because it is sensitive to emotional experience. It is potentially most powerful for those with a passion for it. Passion is contagious. I have a passion for watercolor. And I'd like to share that with you.

This book—supplemented by my paintings and drawings—presents a series of ideas about how to explore the possibilities of watercolor. These ideas emerge from my own experience in making art, although I am not necessarily aware of them while I make the art. There is nothing sacrosanct about any one idea, or about the order in which they are presented. Most beginners experiment with the tools and the medium before being concerned with the subject of their paintings. Keep in mind, though, that paint itself—the colors, shapes, composition of abstract marks—is a possible subject of painting.

Each subject area, for example, animals, is first viewed from my experience with it—which provides a general model of my approach to painting. Then I list possible approaches to the subject in that chapter, which you may try on for size. Some approaches focus on your inner life, and some take nature as a model. Yet, neither an inner nor an outer focus is better than the other. Like blue and brown eyes—eyes are different from each other in color, but are equally good for seeing.

These ideas have expanded my experience with watercolor. I hope that if you find out who you are as a painter and follow that path, perhaps you, too, will enjoy making footsteps in freshly fallen snow.

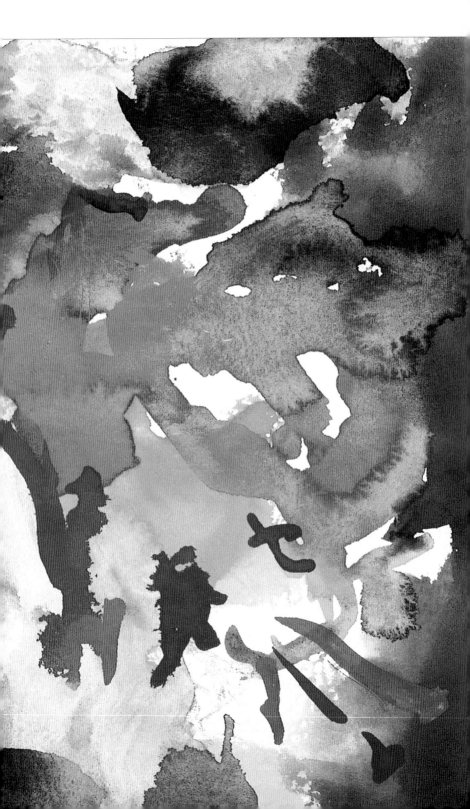

O n e

THE

BASICS

Assumptions of This Book

Everyone has assumptions. Even *that* is an assumption. It's easy to confuse lack of knowledge with having no underlying assumptions. In fact, without knowledge—both factual and self-knowledge—our biases not only exist, they are more powerful. This might sound odd, but think about it. And an idea out of our awareness is also outside our rational control, which makes its influence stronger, since it is hidden from us.

Discussed on this and the next several pages are four major assumptions of this book. Knowing them will help you choose for yourself what you believe. If we were engaged in a two-way conversation, you might ask questions of me, and my answers would help clarify my ideas. But with only the printed page connecting me, the writer, with you, the reader, of course, your individual questions cannot be addressed. That's why it's important that I make clear from the start what the working assumptions of this book are, and are not.

NO RECIPES

First, this is not a "how to" book in the sense that we start out with a technical problem, such as how to paint the sea, or handle perspective, or use pencil in combination with watercolor, and then set about solving that problem with specific techniques, colors, materials, and so on. I have no recipe for painting in watercolor. And I believe in no single

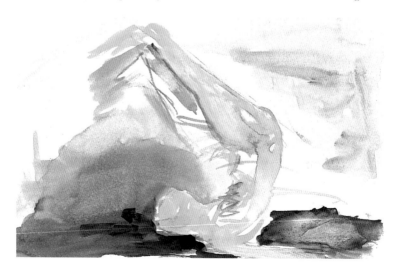

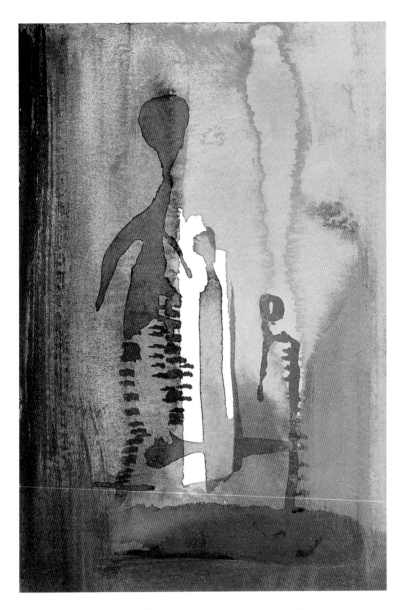

technique that answers all questions. Instead, when technique solves one problem, it creates another. Focusing on light and shade pushes considerations of color into the background. Firming up the drawing in a watercolor with pencil or pen sacrifices some of its spontaneity. We see a tradeoff—something gained, something lost.

What I'm talking about is passion. As you know from the title of this book, I have a *passion* for watercolor, a strong set of feelings and an individual vision about watercolor. My aim in this book is to show you how I tap into that passion. How does it begin? How does it develop? How does it serve me when I find that I've exhausted an aesthetic idea

and need to move on to another? This book is one path to doing water-color—mine, because I know it best. What will you gain from knowing my artistic process? I believe that my general approach, rather than any specific steps, might influence your work in fresh ways.

Here's an example to clarify what I mean. Everyone knows that Sigmund Freud published his own dreams. He analyzed them in print. But reading about his dreams is unlikely to help me know exactly what my next dream means. Yet, his system of dream interpretation helps me understand my dream. In this book about my passion for water-color, I present a way of approaching my preconscious, a part of my personal subconscious that feeds my work. I suggest approaches that work for me—approaches to the preconscious—which you may choose

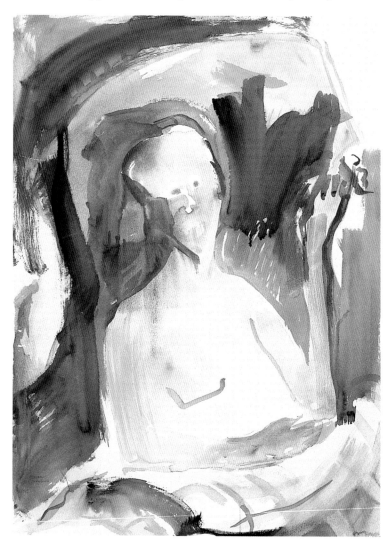

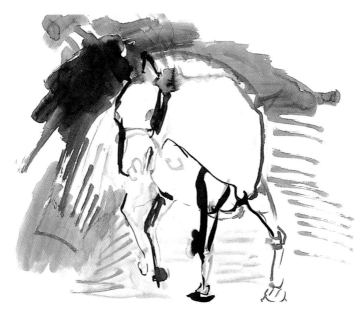

to explore for yourself. These suggestions emerge from a combination of my background in psychology, my emphasis on self-exploration as the goal in life, and my strong wish to communicate ideas with others in words as well as images. By *preconscious* I mean those ideas and emotions that are close to consciousness—not too scary to be conscious of—but have not stayed conscious because they were

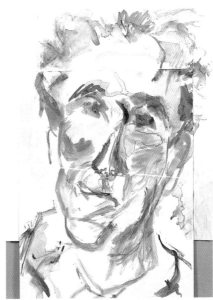

pushed aside by other concerns. As an artist, I work to make the preconscious conscious, and to develop from that source of energy.

If you follow the flow of each chapter, I hope that you, too, will move more deeply into your art. But if you get sidetracked, as I have time and again, you may choose to follow what I call a "thumb path," one that goes off in a different direction from the others. When I've left the straight and narrow, I've often been pleased with the results—with the work and my feelings about it.

A second assumption of this book is that it's necessary to have strong feelings to create strong paintings. Think about it. Francisco Goya cared deeply about social and political concerns of his day, and it shows clearly in his work. Pablo Picasso loved each of the beautiful women he painted time after time, and we can feel the intensity of his connection to them in every portrait. Vincent Van Gogh passionately loved the landscape he painted. He never painted just another tree, just any old tree. Each time he painted the tree of trees, the sun of suns. For me, an artist who loves individual living things, even a scallion can inspire me to paint a portrait of that humble little onion.

Perhaps student paintings look "studenty" in part because students paint according to other people's choices, not guided by their own. Such methods may help students learn, but great work rarely emerges in the classroom. The same might be said for following the approaches in this book. But I think this method differs in some important ways

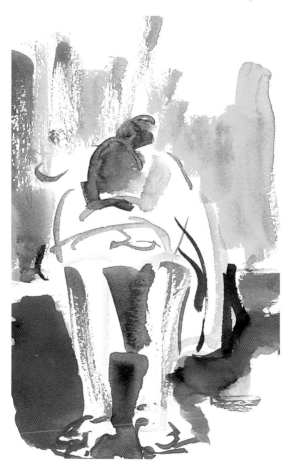

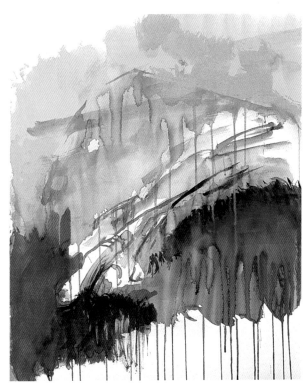

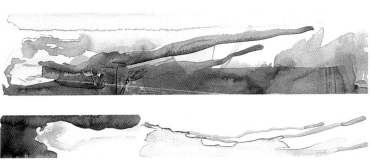

from the standard classroom situation. Here, you are alone when you work—alone with your subconscious in the personal surroundings that you choose. You're not being graded or given a degree, not even an encouraging word. Any rewards you get will be *from yourself* or they will not exist at all. And—don't forget—you choose the order of the approaches suggested in these pages, or whether you try them at all. Some may open up new avenues of exploration, a journey within your own passion for watercolor. It's important to be gentle but firm in your view of your own work. If you are not the one in charge of it, someone else will be. What you do will still be your work—what we do always is—but it will be less sincere and less *you,* and—I believe—less strong as a result of your not making your own decisions.

Here's an assumption to avoid. Several psychological terms running through this book might create the mistaken impression that this book is about self-therapy. But it has nothing to do with art therapy or with psychotherapy. It is about finding and catching threads of aesthetic development fueled by your own subconscious. Whether you understand yourself better or solve your emotional conflicts—and we all have them, little and big ones—is not our issue. Painting is. The point is to get a watercolor approach going for you that is alive and has emotional meaning. Once you're on track, it isn't necessary to delve more deeply into how it came about, or even what should be done about it, unless, of course, you experience personal pain, and then other avenues need to be explored. Approaches to watercolor do not provide solutions to personal anxieties and problems.

But if you are searching for a *way of searching*—of scratching the surface of your subconscious to generate more meaningful work—then you stand to gain from pursuing the approaches in this book as a way to foster your working process as an artist. A successful artistic result is a pattern of strong work, and not the absence of anxiety or conflict. Should stress build at any time in life to the point where it is hard to handle alone, qualified professionals are available to help lessen that conflict and strife. This book is not intended to be of help in that arena; it offers no treatment for pain of any kind.

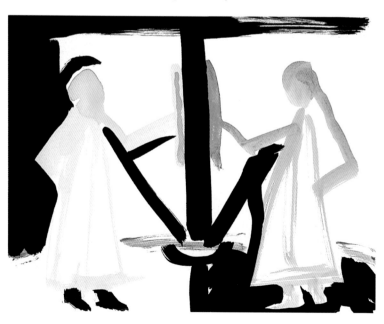

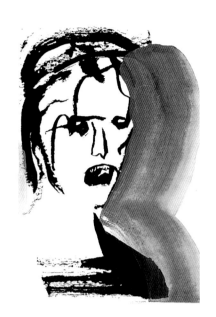

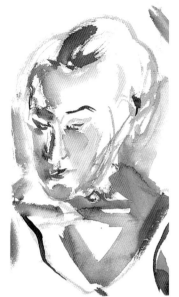

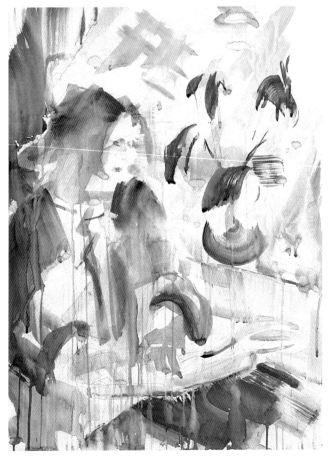

The fourth and final basic assumption of this book, implicit in all the material I present, is that there is no substitute for drawing from life and from imagination as much as possible—and drawing from other artists' work, too. Drawing answers many questions raised by painting—questions about reality, about yourself, and about art. You can learn both from your own explorations and by seeing what thoughts and answers other artists have come up with.

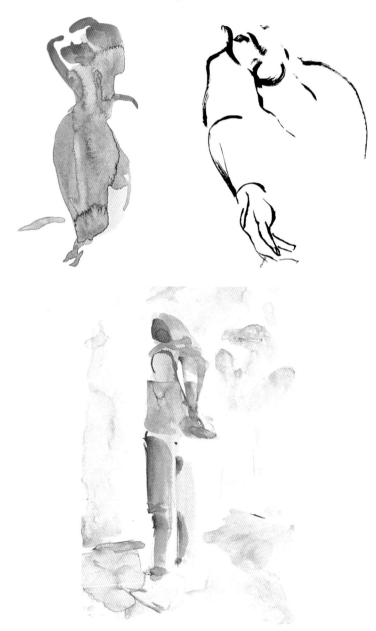

Simply put: If you are dissatisfied with your artwork and want a fresh start, if you find that your watercolors are not as meaningful as you would like them to be and you don't know how to delve more deeply aesthetically, then this book may speak to you. So let's begin.

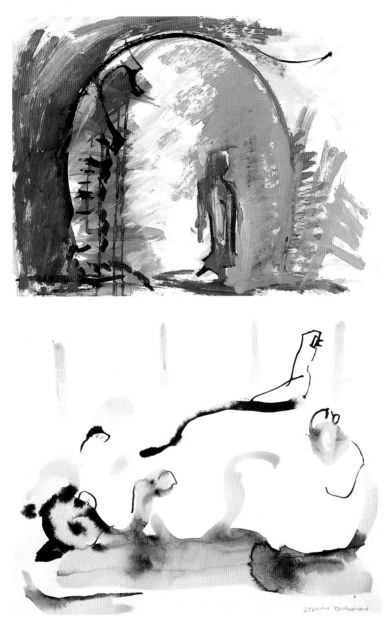

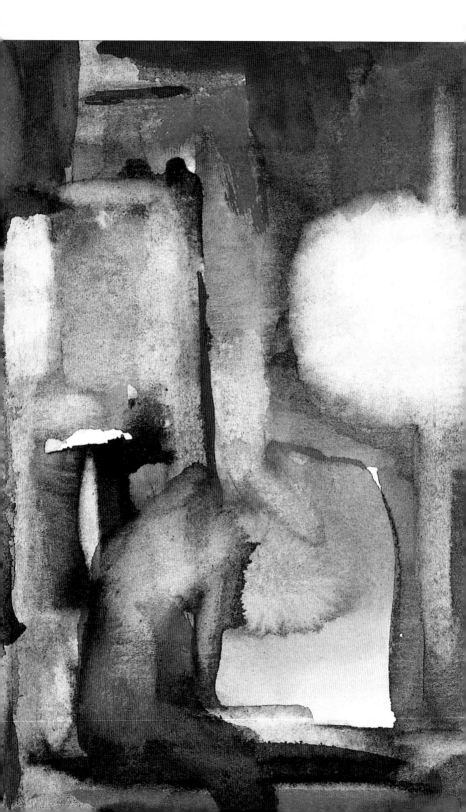

THE

WATERCOLOR

MEDIUM

Materials and Techniques

I remember so clearly the day I bought my first watercolors. I had no plans to do it. But there I was, a young woman on her day off from work, taking a walk near home. When I came to the tiny art store I had passed thousands of times and never entered before, I went in. To my surprise, I knew exactly what I wanted. The whole process took ten minutes. For most of that time, the clerk carefully rolled my brushes in paper and secured them with tape.

I chose six watercolors in tubes: cadmium yellow, cadmium orange, cadmium red light, ultramarine blue, viridian, and burnt sienna. I also bought a small round palette, two brushes—one round, medium-size

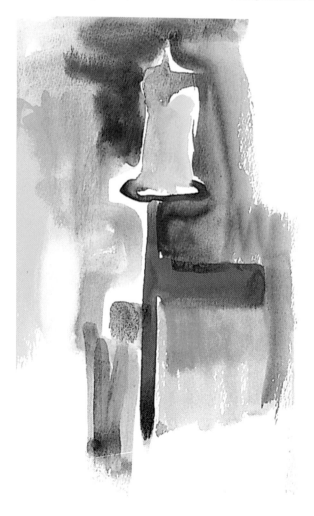

sable and one larger round ox hair—and a spiral-bound, 8" × 10" multi-purpose pad of paper of moderate quality. I brought the small parcel home as if I were carrying a secret—like knowing I was engaged to be married, or had just passed my final exam with flying colors. No one on the street knew what I'd just done. And I had no idea how much those paints would change my life.

I set up an old card table that my parents had just discarded, spread newspapers over it, and laid out my supplies, then gently held each tube with the cap still on, pressing it between my thumb and index finger. All the fresh tubes were soft yet resilient to my touch. I filled a clean jar with water. My two dry brushes lay near the pad, and I proceeded to fill my palette with color—one squeeze of paint from each of the tubes into the separated circular depressions in the palette. Then I tenderly dipped the small sable brush into the blue paint diluted with lots of water, and drew what was in front of me: the kitchen table with

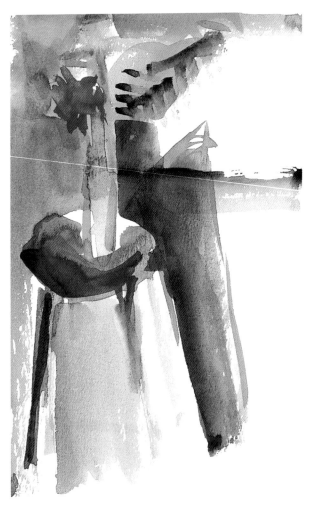

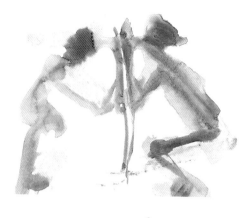

a vase and some flowers, then a window, then a doorway in the distance, anything I saw—just to begin painting.

When I'd done as much as I could with that first picture, I let it dry. The next day, I painted another picture, but this time, to separate it from other sheets in the pad so I could begin my next painting, I tore it from the pad while it was still wet. My colors ran all over the place; I had destroyed my work by removing it from the pad prematurely. So I made another painting right away, but I didn't like that one. Discouraged, I left for work. It became my habit to get up early in the morning to paint before going to work. It made my day go better.

Early next morning, I looked carefully at all three pictures and they didn't look half bad—even the one prematurely pulled from the pad. But I waited until at least the following day to evaluate my work critically. The excitement of painting or drawing, when I'm as unself-conscious as possible, is not a good mind-set for evaluation. Digging into the preconscious emphasizes openness and receptivity, while self-evaluation is critical and tends to close me up—to tighten my work or my approach to it, making it easy to overvalue or undervalue what I'm currently doing. A little time still makes me more objective about the quality of my work.

Once I had figuratively wet my feet with watercolor, working on my own for a few years, I took a semester's class at a local art school. The

teacher had been painting in watercolor for forty-five years, and had been teaching it for almost as long, so he knew exactly what he was doing. He has since died, but my gratitude to him has not. I was lucky to have worked with him.

As I write these words years later, I'm surprised that many aspects of those first attempts at watercolor are still part of my daily work routine. I still use a round plastic palette, although a larger one (12"). Another palette you might try is an ordinary white ceramic dinner plate reserved just for painting (never use it again for food), although it doesn't have the depressions to separate colors, if that's important to you. My watercolor brushes—usually round and made of animal hairs—are thicker than I used to use, and often have bamboo ferrules. A ferrule is that part of a brush (usually metal) that surrounds and secures hairs to each other and to the brush handle. And I still buy at least middle-quality, if not high-quality, paper for watercolor; I've never liked the feel of newsprint.

I continue to use high-quality paints—those same colors, plus a few, remain the mainstay of my color preferences. Now I realize these are mainly prismatic colors—the colors you get when you shine light through a prism—more like the colors of a rainbow rather than earth colors. However, one transparent earth color, burnt sienna, forms a wonderful midpoint between reds and blues on my palette.

I arrange my colors from light to dark and from yellow through orange, red, alizarin crimson, burnt sienna, and then back again from dark through light with violets, phthalo-green or viridian, ultramarine blue, and ending with cerulean blue. In a circle, the lightest yellow and the lightest blue are adjacent to each other. That way, should they mix with each other, it is mainly a color mixture rather than an abrupt value change—a change in the lightness or darkness of a color independent of its hue. For example, if a

powerful color like phthalo blue accidentally mixes with yellow, the resulting painted area would not only be a bright yellow green, it would also be much darker than if the adjacent color had been cerulean blue which, mixed with yellow, yields a softer and paler yellowed green.

The danger of sudden, relatively uncorrectable value changes being confounded with color changes keeps some artists from placing colors with powerful staining properties on their palette. Yet, I like intense and dark colors on the palette, as well as delicate ones. I like contrast, and I often mix my own "blacks," using combinations of deep colors rather than using black watercolor or Payne's gray. I prefer the variety of darks I mix myself. Sometimes I use black water-soluble ink and let it blend with the prismatic colors for other subtle, interesting darks.

Once I've squeezed out the colors, I let them dry. That way, I can use and reuse the colors time and again. There is no waste, since water-

colors dissolve and redissolve repeatedly. When the colors are almost used up, I squeeze more on top of them and go on from there. This means, however, that once a palette is established with its order of colors, I use it that way. If I want to change my palette—as happens at least every five or ten years—I simply buy a new palette and prepare it from scratch with different colors or an altered arrangement of previously selected colors.

By the way, I don't keep my palette too clean. Yes, I mop up any huge puddles, but I leave the little residue and puddles that remain and let them dry. Later, they give hues a color edge, a novelty, a subtlety that straight tube colors do not have. I prefer shades of color that are slightly off the pure red, blue, or yellow. Sometimes I contrast those so-called "grayed" colors with pure colors, but that is an

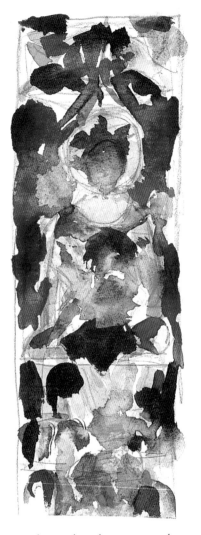

intentional color statement for a particular work and not a general painting principle. While I usually prefer transparent watercolors to opaque ones, I have absolutely no rules about transparency. If I feel that using thick paint or a nontransparent white is helpful, I do it. If you have reservations about doing that, just look at John Singer Sargent's watercolors and see how beautifully he integrated transparent with opaque in his paintings. However, opacity controls, puts a limit on the freedom of the transparent watercolor.

My approach builds on what I have learned from painting for over thirty years. As we move into the technique section of this chapter, do remember that if you find you prefer a rectangular palette, square brushes, or any other materials that differ from mine, please use them. I sometimes do, too, and even use shaving brushes or pastry brushes that I keep on hand for exclusive use with paints.

A p p r o a c h e s

If you've never painted before, or are just curious about trying this way of working, that's great. Here are some techniques to familiarize yourself with the medium while trying some different approaches to it.

ONE BRUSHSTROKE AT A TIME

Watercolor paper comes in "rough"—which has a lot of tooth, or texture, to it— "hot press"—which is smooth, and "cold press"—which is somewhere between the two. To start exploring, when you have a few hours in one stretch, take a sheet of cold-press watercolor paper (no bigger than 18" × 24") and tape it to a board that is raised about an inch higher at the top than at the bottom, inclined to the tabletop. Think of covering the page, one stroke at a time, with a soft grid of individual brushstrokes to experiment with the medium, its wide range of color, and its value possibilities, that is, range of dark and light tones. Start in the upper-left corner, if you are right-handed. (Left-handers begin in the upper-right corner so you can see what you're doing.)

Wet a #12 round, pointed brush in a container of water *(never in your mouth)*, and dip it in any color. Hold the brush (not too close to the ferrule) loosely enough not to tire your hand, yet firmly enough to maintain control so you can give the brush a little play. Find just the right amount of wetness so that when you place your color-loaded

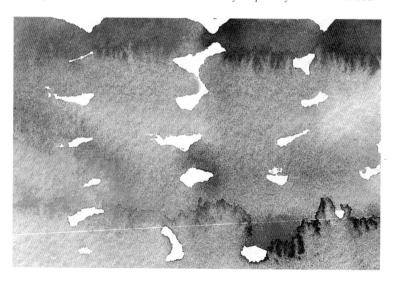

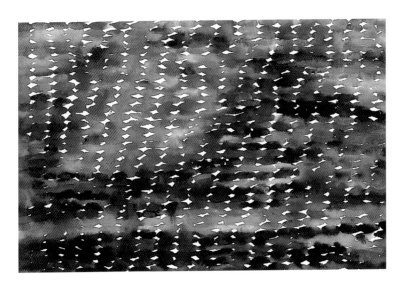

brush on the sheet in the far corner, making a mark parallel to the top of the paper, that mark is drier on top and leaves a small puddle on the bottom of the mark. The puddle should not run, nor should it dry up right away. It should sit there comfortably until, in forming the grid, you get back to it. Dip your brush in the paint again and make a mark of a different color so that it rests right against the side of your first mark, but neither overlaps it nor leaves a gap between the two strokes. It, too, leaves a puddle. This may not be easy to do at first, but don't go over your stroke if it doesn't come out right. Just go on and learn from what you've done. When your painting dries, you may notice a small section of white paper showing through at the corner intersection of four strokes. That space can be made smaller with practice. If the puddle runs clear across the row, your brush is carrying too much water. Blot it a bit before resting it on the paper for the next stroke—which should be drier but not so dry that it leaves no puddle at all.

Now you have two marks in a row against the top of your paper, each with a persistent but not drippy puddle at its base. Reload your brush and make a third mark right next to the second mark, and so on, until you've made one straight line of marks along the top of your sheet. Remember to reload your brush with paint of any color(s) of your choice each time, before making a new mark. This procedure can take hours and it may try your patience, but it's important not to use the same brush-load more than once. If you do, you'll miss the whole point of getting to know the watercolor medium.

Next, return to the left edge of your paper and begin a line of strokes right under the first line, barely catching up the puddle from the stroke above. This means that you lose that row of puddles in forming a new

row of puddles at the bottom of the second row of strokes. As each stroke "catches up the puddle" from the stroke above it, there is always only one row of puddles at a time across the page. Continue until you finish the second row all across, then a third row starting from the left, and so on, until every line is filled up. You have *not gone over* any stroke from upper left to lower right, and now, with your last stroke at the farthest lower-right corner, your picture is finished.

Observe the variation in colors. How similar are each of your strokes? For example, are your strokes mostly reds or blues or equal mixtures of the two? Are they all light, all dark, or is there a range of values to your work? Are all your blues the dark strokes and all your reds the lighter ones? How do the puddles alter and modulate the color of the new strokes mixed with them? Look closely at what you've done. There are innumerable colors on your paper from just a few tubes of paint, some that may never have been made before by any other painter, and some that you may never make again.

PAINT A SHAPE

This time, place a simple form in front of you, any shape that pleases you— perhaps a cup, a vase, a spoon. As with the study above, this one is also based on a grid and will take some time to complete, but it should be done in one sitting, otherwise the puddles will dry up and your painting won't be completed in a consistent way. Work from upper left to lower right on your paper, but place your object on a

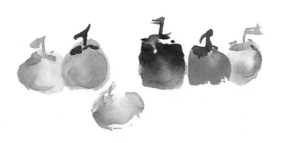

table against a background color. Think about hue and value choices while you make your grid, such that when you are finished at the lower-right side of your paper, you can easily look at your picture and see the object on the table. It won't be a photographic representation, nor should it be. But unlike the purely exploratory color combinations of the earlier painting, this one should show planning in color and form, so that your simple object emerges from the pattern of your uniform strokes, which capture the puddles from the line above.

WET-ON-WET

Both previous techniques use a wet brush on dry paper. Now try work-ing on moistened paper—a technique known as "wet-on-wet."

Immerse a sheet of 140-lb. cold-press paper in clean cold water. The sheet should lie flat in a clean sink or pan, left just long enough so that the paper has some play to it when you pick it up. If immersed too long, the paper texture can disintegrate. Once your paper is wet but not soggy, place it on a wooden board and tack or tape it down around all four sides. Since paper tears more easily when wet than when dry,

be gentle. Now, while the paper is wet and anchored, take a brush loaded with color and apply your first strokes. Watch the paint run. See how colors spread from the more concentrated paint through the water-soaked paper, producing a traveling color effect. The hues may look bright, even brilliant where they were originally applied, but remem-ber that watercolor painting dries lighter than it looks when it's wet.

Some people find the wetter techniques just too hard to control, too frustrating, so "drybrush" is often the method they choose. Here, the paper is completely dry and the brush is barely moist enough to carry pigment. This kind of painting can be interrupted and returned to. You can make an entire painting in drybrush, or you can do what most watercolorists do—combine dry strokes with wetter ones to make your own specific balance of the two. This can even involve wetting a portion of the paper before applying paint, while leaving other sections bone dry.

Try water-based black ink and see the interesting effects you can achieve by brushing it on wet or dry paper. Using black ink on white paper, you can create the greatest value contrasts possible. If that appeals to you, build on it with washes of ink or even watercolor.

Chinese painting theory holds that all colors can be experienced through black ink on white paper. Not that we actually see the hue; rather, the image is so well executed that it calls color to mind, makes us "see" the red color of a peony or the blue feathers of a bird.

Textured effects can be produced with watercolors. The paint can be scumbled—whereby a relatively dry brush is dragged across a dry painting in such a way that it does not completely cover the underlying color. Scumbling produces a shimmering effect of light on dark or of one color against another. The texture of the upper layer is readily visible and adds another level of variation.

You can also create textured effects by drawing into thick wet paint with a palette knife, a brush handle, a plastic fork, or similar tool. I even

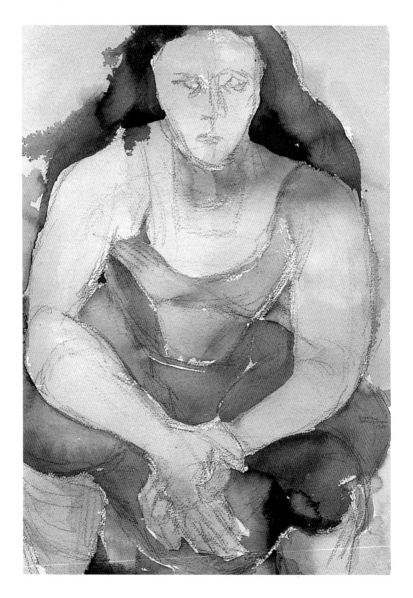

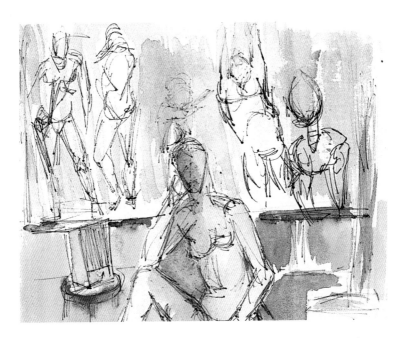

make marks with my fingers—a technique that began with our earliest ancestors, who used their fingers as tools to make distinctive marks in their cave paintings. When I use my fingers, and, in fact, whenever I paint, I wear disposable latex or plastic gloves. Some colors can be harmful if they get on your fingers or are accidentally ingested, so read and follow the handling instructions on each tube of paint before using it.

STUDY GREAT ART

Learn by looking at other art, everything from cave paintings to the old masters to a range of contemporary paintings. I learn by making drawings "after," or inspired by, great works, and even more by doing watercolors of them. Chartres Cathedral's stained-glass windows or the paintings by Mathias Grünewald for the Isenheim altar have been wonderful teachers. Doing watercolors of them showed me the simple, large shapes that form their fundamental composition. But note that if you sketch at a museum, there are likely to be specific regulations relating to safety and the flow of people through the galleries that restrict when and where you may work, so always call ahead to inquire about rules. Where art is shown in a place of worship, you may not be permitted to draw at all. In that case, reproductions and photographs of art can be good teachers, too, in spite of their reduced and altered information as compared with the works themselves.

Finally, I enjoy taking a book that I love and illustrating it. Think of a work of literature that is especially meaningful to you, and try to interpret scenes from it in a series of watercolor paintings. Rembrandt worked from biblical images, other artists have been moved by novels, plays, or poems. Search for anything that was originally expressed through words that you find stimulating enough to use as subject matter for one or more watercolor paintings.

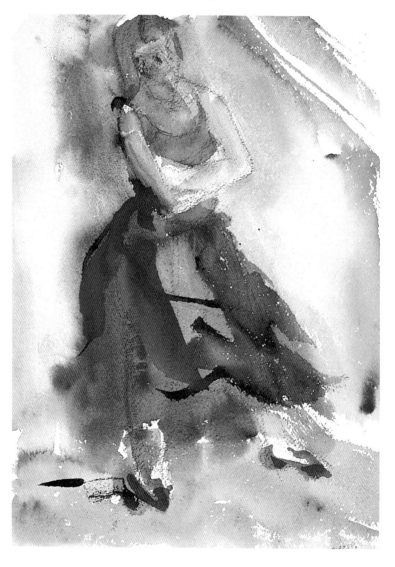

I cannot say this too often: There is no one way to make a strong water-color painting. Ultimately, there are probably as many ways to use materials and apply techniques as there are people. Yet, we all need to begin somewhere, to learn how to approach our blank piece of watercolor paper. Perhaps there are some agreed-upon conclusions, but artists can never be expected to agree on all of them. Personally, I wouldn't want them to. I love the variety of what watercolor can do in different hands and with alternative visions—or by the same hand at different times.

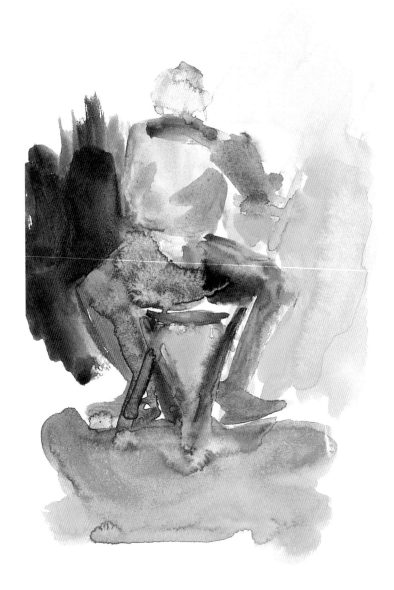

SUBJECTS,

APPROACHES,

AND THE

ISSUES

THEY RAISE

SUBJECTS ARE EVERYWHERE

Food

With subjects everywhere, the question becomes: What shall I paint? Each chapter—accompanied by images of my work—offers ideas on which to rest your colors, forms, and compositions. Some subjects, such as flowers and fruits, are things you probably painted in school, as a child, but painting them now will be a very different experience in the context of the aesthetic issues raised in each chapter. So let's start with food as subject matter.

For everyone, the everyday event of eating, like Mount Everest, is there and is a daily climb. We care about food, not just eating it, but looking at it in markets, seeing images of it on our walls, wearing it as patterns on our clothes, or woven into our rugs. I remember a beautiful Chinese carpet in deep blue with delicately formed bunches of red cherries in two corners—cherries that looked luscious in spite of being made of wool.

Food is not only tied to life; it is also tied to emotions. We learn that food is love (a birthday cake); a weapon (to be withheld or thrown at

someone); a medium of creativity (for gourmets); a source of status (you can tell a family's social class from its garbage). Food hits us at the center of our being whoever and wherever we are.

Painting of food runs the full gamut, from the delicate watercolor images of fruit on a plate by Charles Demuth to the stark representations of sides of meat by Rembrandt or Francis Bacon. In these paintings, food is the apparent subject. But in other instances, food is indirectly painted in myriad contexts: images of nursing babies in religious and secular paintings; depictions of the Last Supper; Dutch interiors as in Rembrandt's self-portrait toasting his bride; Jan Vermeer's young girl pouring milk from a pitcher; Picasso's images of poor people eating a simple meal; Peter Bruegel's famous wedding banquet.

Am I seeing food in paintings where it is only minimally referred to and isn't really important? I don't think so. I believe that eating is so

fundamental to daily life that it's impossible to conceive of painting nature without food taking a monumental place in our art. I have no difficulty extending the subject of food to symbolic representations in mother-and-child images found in Egyptian sculpture, in massive pieces by Henry Moore, and in delicate paintings by Mary Cassatt.

In fact, the food we eat and the way we eat it could be a substitute for an actual portrait of a person. Andrew Wyeth, in his image of a country kitchen with plate and knife on a sparse white table, tells us as much about the person who will sit and eat at that table as any photo-realistic representation of the shape of that person's nose could tell us. Perhaps more. Why? Because personal choices say a lot about a person. A room setting, how things are arranged in it, and even breakfast foods on the table can describe a person more accurately than the shape of that individual's nose, which had nothing to do with personal choice (short of having had cosmetic surgery).

And what about garbage; can we tell what people are like by seeing the food they throw away? We enjoy pictures of food steaming or nicely chilled, set before us beautifully to please our palate. But is it still food when it begins to decay? Can you paint decay? What does the smell of chicken kept too long look like? Can that be a subject of art?

Rembrandt made a side of meat at the slaughterhouse beautiful. Vegetarians—appalled by images of flesh to be eaten—can paint their experience of full-bodied acorn squash or a colander of fresh apples ready to be eaten uncooked or made into pie or apple sauce. Or they could paint their revulsion to eating meat. Or paint the compost pile where apple peelings or fallen apples ready themselves to rise as next year's vegetables.

I sometimes paint eggplants. The purple color, deep greens, blues, and carmines in the shiny skin move me. I love the firm and curving shape of the form. Eggplants offer a wonderful opportunity to paint watercolor darks. The beginner is sometimes afraid of dark paint and avoids it. But a faintly painted eggplant looks unhealthy. Painting darks

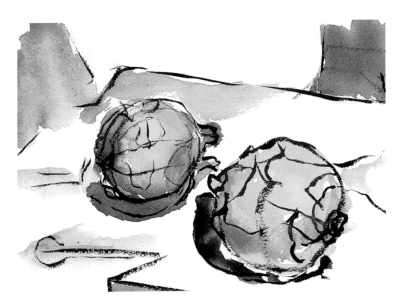

lets deep, rich colors meld into each other while forming the solid shape of the vegetable in its surroundings.

Once discarded, could peelings of an eggplant sitting in the sink be seen as weaving into and out of each other, forming an abstract image of flat planes or rings? Could peelings be painted surrealistically, becoming snakes writhing in the sink? Consider a progression that moves from painting the vegetable relatively realistically, to its becoming an organic, two-dimensional design with no necessary reference to content—that is, to "vegetableness"—and on to painting an identifiable mathematical concept the forms bring to mind, and finally to letting your imagination go a little wild as you paint the vegetable forms as if they were coming to life or even moving.

Vegetables or fruit may also be part of a more complex still-life painting—that is, shown in conjunction with cups, bowls, flowers, and other items—usually placed on a table in an indoor setting. But couldn't that eggplant be painted while it is still on the plant? Would it make a difference in how it is painted? What about painting string beans hanging from their stems, still alive, still growing? Pumpkins make good subjects, too, ensnared in their own huge leaves and in each other's vines as they grow large, almost before our eyes.

Thomas Gainsborough sometimes painted his remarkable landscapes by arranging bunches of broccoli and other vegetables on his kitchen table, using them as models for the shapes and contours of trees, hills, and other elements. Yes, he already knew what trees and hills looked like and how to paint them, but he also knew that compositions could be strengthened by working with nature's forms in this unusual way.

A p p r o a c h e s

I've never met an artist who doesn't love to eat well, even on a tight budget. Food made beautiful nourishes heart, soul, and body. No wonder it's often a subject for artists. Here are approaches to consider.

PAINT A SINGLE ITEM

Start simply, with a single, wonderfully contoured eggplant or pear. If you choose to paint a pear, there are many varieties to consider, such as bosc, comice, and anjou; go to the market and look them all over. Once you've selected a single pear whose shape, color, and texture are pleasing to you, paint it in many positions. I like the pear because of its well-defined shape, and being larger on one end makes it more likely to rest solidly on the surface in your painting. Unintentionally "floating" objects are a problem for some beginners, but an eggplant or pear is less likely to float on the page than a round shape like an orange, which only touches the surface in one place.

After you've exhausted the painting of a single fruit or vegetable, you might put two of them together or add different shapes to your composition. You could even try building a landscape from vegetables just as Gainsborough did.

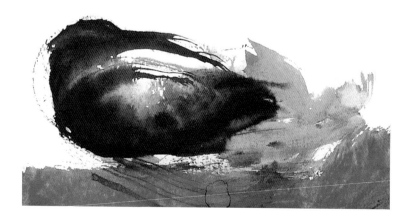

Look at what's left on your plate after you've finished a meal. Are there any interesting shapes or colors that move you to take out your water-colors and begin painting? Perhaps a tableful of dinner leftovers will even provide enough inspiration for a second and third painting before you gather up and wash your dishes. Approach these paintings as abstract compositions or as realistically portrayed food items.

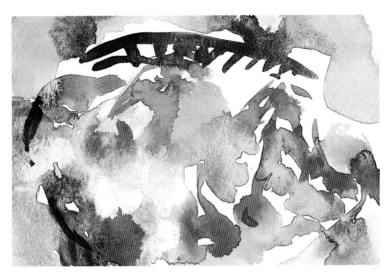

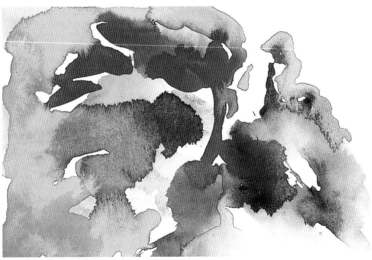

Try painting food to represent a portrait of someone you know. A table place setting, showing a plate filled with food next to utensils, a glass, a cup and saucer, can communicate a great deal about the person who will partake of that meal, without that person ever being in the picture. What does the choice of food and tableware say about an individual? If leftovers are depicted on a plate, what might they tell us about the diner? Do we each leave food on our plates in different ways—neatly to one side or spilling over the rim? Some people leave a large portion of food, others just a token pea, others may wipe their plates absolutely clean—among them, perhaps someone who has known hunger and can never forget that food is not to be thrown out. Images of leftover food can become powerful characterizations of specific individuals.

UNLIKELY SOURCES HAVE POTENTIAL

What about a trash can or a garbage truck as subject matter? Or perhaps that compost heap in your backyard? Or the colors on a moldy lemon that's been in your refrigerator too long to be edible—but might it be right as a fascinating painting subject? Of course, if you are completely revolted by the sight of decaying food, leave the painting of garbage to others— or use those feelings creatively by painting that revulsion.

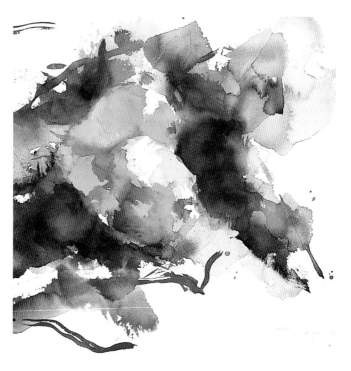

If you have the opportunity, you might paint fruit or vegetables outside, as they are growing. It need not be on a farm. Even a small garden, or a single tomato plant on a windowsill might do. Do you experience food differently by painting it still growing rather than once it has been cut down, and is no longer technically living?

You might consider food symbolically. What do these specific foods mean to you: bread, milk, a slab of rib roast just coming out of the oven, a potato, or a single clove of garlic? Worlds can be created from such images—portraits of entire societies or periods in history. For example, picture three people in simple clothes seated around a single candle, with no other light source. Three small bowls are set before them. Someone quickly fills each bowl with steaming broth, poured from a pot that has three eggs floating in it, one for each person. Doesn't that describe a way of life, a time in history?

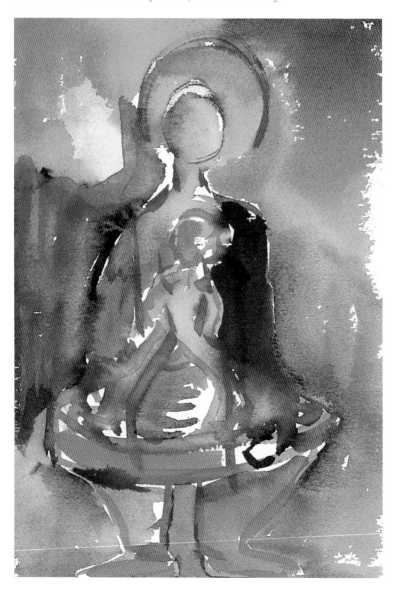

When you paint, you are in charge, you are the boss. You decide what and how to paint—subjects are everywhere. Every decision in a painting and every brushstroke reflects the artist. Viewers are free to react, and you cannot control that. But finding your own voice—your subject matter as well as your way of expressing that subject with watercolors—is your task as an artist. Many talented people who are good at their craft never find their voice in subject or medium. Perhaps they feel stuck painting only pretty things, or what others are painting, or what's selling at the moment. Don't be slowed down by such thoughts. Paint what you find interesting, paint it sincerely, and I believe that at least some others will find it genuinely moving and meaningful.

LOOK CLOSELY

Tree

At the 1992 World's Fair in Seville, the Hungarian Pavilion was designed so that it had one foot in the twelfth century and the other in the twenty-first. In the central room of the building, visitors walked on a glass floor, lit only from the floor below. They looked down to see the roots of a tree. The whole uprooted tree constituted the focus of attention in the room, with the upper trunk and branches on the top floor where the visitors were standing, while the roots and lower trunk were seen under the glass floor. With no ornaments, not even leaves, the tree stood majestically filling the large space, asking for nothing more than a person to be in the room with it.

"A person and a tree," "A person *as* a tree," are ideas that percolated in me while I spent two years painting for an exhibition called "I Am a Tree." The poem I wrote sounds my theme for that show.

> *I AM A TREE* ©2000 *Stefan Draughon*
>
> *Imagine a tree so full of energy it dances.*
> *Imagine a person with spreading subterranean roots.*
> *Imagine the two in one.*
>
> *Imagine the drag of gravity on her body.*
> *Imagine the thrust of her tree in motion.*
> *Imagine "always."*
>
> *Imagine tension.*
> *Imagine me.*

How did it start, my trees? How does a city person satisfy a deep hunger for the sight of a tree and even for existence as a tree? For the first time in years, I had left my studio to work outdoors, left my imagination, left that familiar space—not to draw the model in another enclosed space—but to draw from nature on her turf. Even as I write this years later, I smile while I muse on that World's Fair pavilion, its tree stepping out of its glass enclosure and slowly, elegantly strolling from the fairgrounds in Spain, returning to its family in the beautiful parks of Hungary.

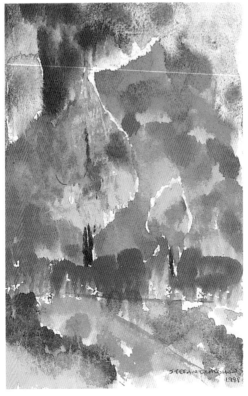

Like my daydreamed tree, I, too, needed to escape confinement, to get out into the "real world" and paint the landscape—but at other times, I looked at trees and painted only the "tree" aspect of myself, finding that experience to be totally different from creating complete landscapes (which appear in another chapter of this book). I had become entranced, perhaps even obsessed, by the *single* tree, the tree as portrait, the tree as self-portrait, the particular tree. Specific shapes caught my eye, shapes of the flowering cherry tree in spring, with its gnarled branches reaching out, lush and covered with clustered pink-and-white blossoms. A nearby oak stood tall with one or two leaves from the previous year still hanging limply from its otherwise bare branches—as if it were observing "my" tree and me objectively, wisely. The cherry tree was a metaphor for my reaching out to life once more.

I returned to my studio with dozens of sketches of the cherry tree in bloom, but I also carried back a stabilizing image of that particular cherry tree—engraved in my mind. I painted it from memory, having absorbed the structure into my being from drawing it repeatedly.

I used every medium to search for my tree: pen, pencil, ink, charcoal, pastels, and of course, watercolor. But when I got back to my studio, I immediately found that I needed an opaque medium to continue searching for the structure of my tree, right on top of my earlier images. Transparent watercolor, with its characteristic of leaving every stroke visible on the paper, would come later in this exploration; for now, acrylic paint was more suited to my task. While still water-based, it was opaque enough to allow immediate adjustments in form and structure of my tree and its surround.

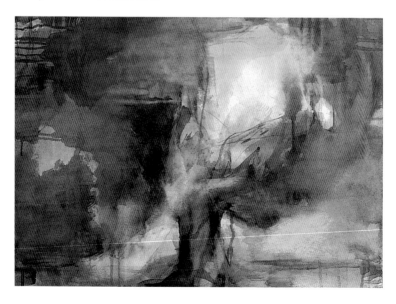

I worked layer upon layer of paint, each layer hiding the previous one, until I found myself comfortable with the result. I also found that toning the entire surface with burnt sienna before painting on it created the effect of light on the blossoms. Once I'd crystallized my idea of a tree, I shifted to transparent watercolor on white paper. That went better now. I could create the light of trees with color on the white paper, but I was still not pleased with the composition of my paintings. I liked the shapes of the trees, but they needed to be set into a context that was as developed as the trees.

Again, I used opaque paint, white or another color on top of the painted watercolor, to unify the composition. Using gouache, casein, and acrylic paint over the watercolors provided interesting effects, as did using black ink selectively over the watercolor forms.

But I wanted still more from these images. So I cropped them to enhance the compositional elements. I cut and cut, often retaining only a tenth of the original image, until I was satisfied with the whole. If I cropped too much, of course, I couldn't stick it back together again. Or could I? I glued the cut piece of my watercolor not just next to, but attached to, another part of that same watercolor. Then I had all the flexibility of opaque, without the opacity. I also developed a set of collaged watercolors.

I worried about putting up a solo show in more than one water-based medium. Would the various images hang together? They did. Dark acrylic paintings and light watercolors, varied value images with and on paper, all traveled together and belonged to the same aesthetic world. It could have been otherwise, but it wasn't. I had struggled long to find my way of working, my "style"—a combination of color, form, composition, brushwork, and more—that presented itself in image after image. I sensed that the collaged paintings were a step in the development of my evolving style—that I would return to paint and to drawing.

My "will" helps me to paint every day, to avoid meaningless distractions that keep me from painting, to organize my studio and purchase my needed supplies, and still see to myself, my family, and other

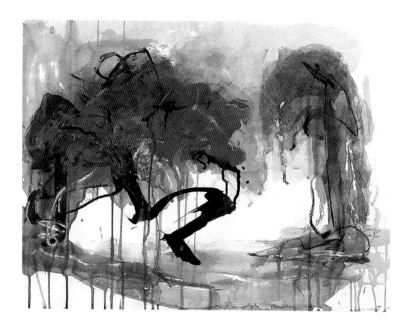

responsibilities. But my will alone is useless in determining my style. In fact, my will can hold me back as an artist. It can get in my way or lead me astray. For example, I once decided to make purely commercial water-colors for hotels. I was skilled enough, I knew someone who could connect me with the appropriate market, and I needed the income. I made a dozen pieces that were as "general purpose" as I could paint them. The buyer in charge of the hotel art loved my paintings, but said they were useless for his clients. They were "too personal." Not the content of the images, the flowers and landscapes; the "personal" parts were in my brushstrokes. But I could not turn my "style" on and off at will.

I need a balance between the "will" that gets me to work and my more intuitive and subconscious elements that take charge during the aesthetic process of painting. My subconscious searched not for photographic images of trees, but for their essence in paint, for images that would make viewers feel the tree, see the tree in their mind's eye, and see themselves as one with the tree I painted.

Perhaps finding myself as "tree," and my aesthetic shift from baroque and expressionistic to more classical and formal, are one and the same, parallel shifts both in my character and my art. I could speculate on that theory. But I have come to believe that there is only one way my work can go, and I must find that way. When the work feels right, it is right. If I feel distanced from it, the work must change, even though I may like and respect that aspect of other people's work. I must forget what no longer feels right. I cannot duplicate a painting today that I created years ago. I'm different, now from then, and can only paint now.

A p p r o a c h e s

As you develop as a watercolorist, perhaps your painting will evolve, or perhaps you've already found your "style." In any case, periodically, artists try new approaches just to test the waters. Here are some streams of thought and technique to explore.

LIMIT YOUR FOCUS

Many people give up painting on location out of doors, because they find it to be overwhelming. There is so much going on; everything is in constant motion. The wind blows, the light changes, insects and other animals come into view, and then there are the people, the onlookers. Admitting all the possible distractions, what if you were to work outside, focusing your attention on just one element? In my case, it was a flowering cherry tree, but in yours? Perhaps another kind of tree catches your eye, or a small cluster of wild violets at your feet that you normally would ignore or even step on inadvertently. Draw or paint what catches your eye,and stay with it. Make that the subject of your painting, and see how long you can sustain your interest in it. Portray it over and over again—changing the composition, the color, the values of your work, move up close, step far away.

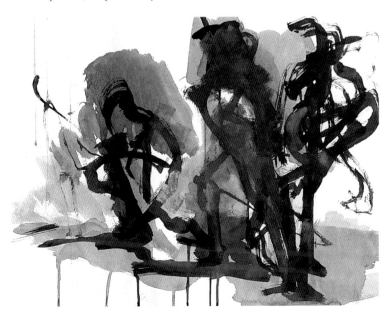

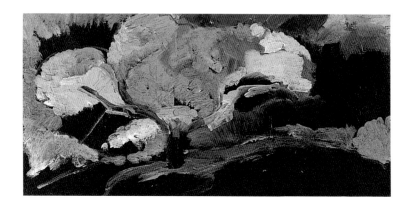

TAP YOUR IMAGINATION

Once you've worked with an image for a while, you may find that
you think about it even away from your work space. Try tapping into
your memory and imagination and paint the image both from your
conscious knowledge of it and now also from its place in your sub-
conscious. Let the image enter and travel in your mind's eye, and let
your hand and eye travel—not rush back to those violets or the model.
Instead, even literally turn your back to the subject—some artists
work that way from nature—so as not to be bound or stifled by it.

See if you like these images done
from imagination as well as, or even
better than, the ones you did from
life. I find each approach useful at
one time or another, but as time
goes by, I spend more and more time
drawing from life until the image
becomes mine, and then using that
image to paint from my memory.
Just painting from life provides me
with too great a crutch, so that I
become reluctant to stray from it in
my art. On the other hand, working
just from imagination can lead to
repetitive images, so that both artist
and viewer become bored with the
paintings that are produced. The
third option, drawing first from life
and then moving on to painting
the memory of it, allows me to be

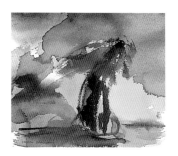

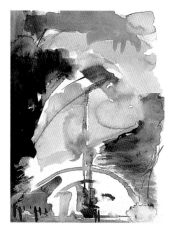

nourished by the richness of
nature, but not restricted to it
or overly dependent on it as an
aesthetic resource.

CONSTRUCTIVE CROPPING

If you find the watercolor me-
dium too fluid to control as you
search for a particular composi-
tional organization, consider
cropping some of your pictures
(a technique many oil painters
have employed for centuries).
Sometimes by cropping them,
your compositions get stronger.
Once you get used to seeing
tighter and more controlled
compositions, your new water-
colors can absorb those lessons
and you may find that your
watercolors are better com-
posed than before.

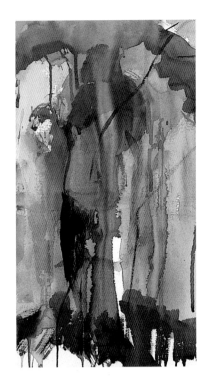

Look at one of your larger
watercolors. What catches your
eye first, which section is most
compelling? Take a straightedge
and move it along one side of
the work until you find ele-
ments of the painting "clicking"
into place and your reduced
composition looks better. After
temporarily adjusting that first

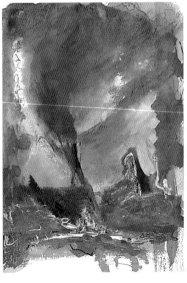

edge, do the same with another straight edge perpendicular to it, and so
on around the painting, until you have corralled your work in a way
that makes it stronger and more pleasing to you. Mark the corners and
move the straightedges away again just to check. Be sure of your final
placement, because once you cut the paper, you can never get it back
exactly the way you had it before.

It requires bravery to cut into your painting. But even if you make
a mistake, you'll learn from it. Next time, move in less tightly on the
image, leaving more open space around it. While it's an easy option to
make a larger work smaller, patching work back together can get messy
and aesthetically complicated. Although paper segments have been
added to watercolor paintings by artists so skillfully that we cannot eas-
ily tell that the image was expanded, it is extraordinarily difficult. Be
sure before you cut into your work.

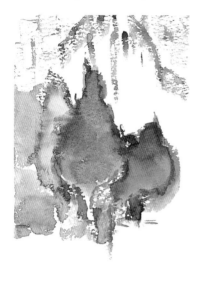
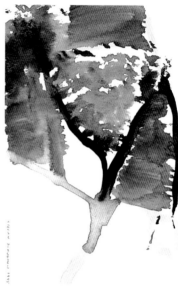

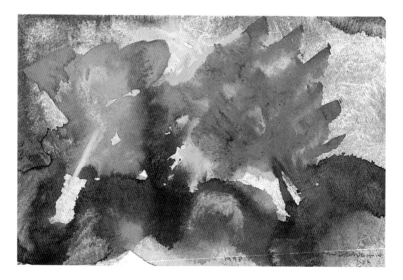

In order to "see" and paint a single tree, a cluster of violets, or any other focused living subject matter, you will need to look closely at nature—if you choose to go in that direction—or inside yourself, if you work from imagination and/or memory. As your watercolor work develops, you will need to look closely at each painting, as well. Is the picture you consider finished what you really want, or do you need to experiment with it further? Look closely, learn, and find what works for you.

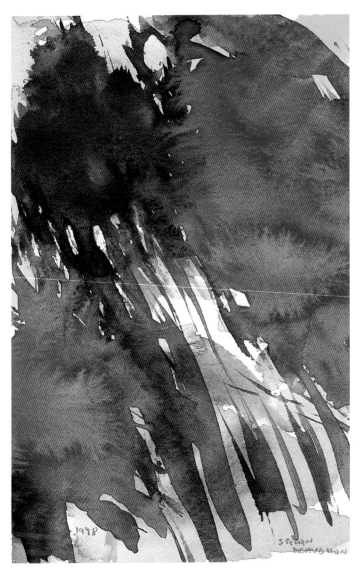

CUTE IS NOT ENOUGH

Animals

When I decided to paint animals, I focused on the one—other than my husband or friends—about whom I cared most: our canary. He was named Conway, after the hero in search of Shangri-la. That name seemed appropriate, since this little bird was courageous and adapted quickly to his environment in the pet store the day he arrived there. I had watched him for two hours and then brought him home. I had no idea whether he could sing, but I knew he was brave and flexible.

The next day, at 5:45 in the morning, he sang lustily, and from then on, he sang often and beautifully. He always seemed to wake up in a good mood, even when construction noises upstairs had disturbed and agitated him the night before. Every day I would watch him busily eating his weight in food just to stay alive, and I was struck by the fact that he was never still. He had his set routine, his own repertoire of favorite body positions—just as people do. But he moved around so much and so quickly that when I tried to sketch him, I could never finish a line or a mass before he was in a completely different pose, often facing away from me instead of facing toward me.

I thought he was just a busy little bird and that was why I had trouble drawing him, even when he seemed to be resting. Then I found out that other artists, with different animals, had had the same experience. Animals often turn their backs to someone drawing them. Perhaps they sense being watched in a particular way and prefer not to cooperate—just as there are many people who resent having their picture taken or being sketched by artists.

Whenever I tried to make a painting of my little bird, my attention would shift from his position to my feelings for him, to the quality of the line as it stood for the bird, to the color and the interaction of the color and the line. I would consider whether the previous brushstroke was dry enough to place another one over it—without losing the impact of the first brushstroke—and so on.

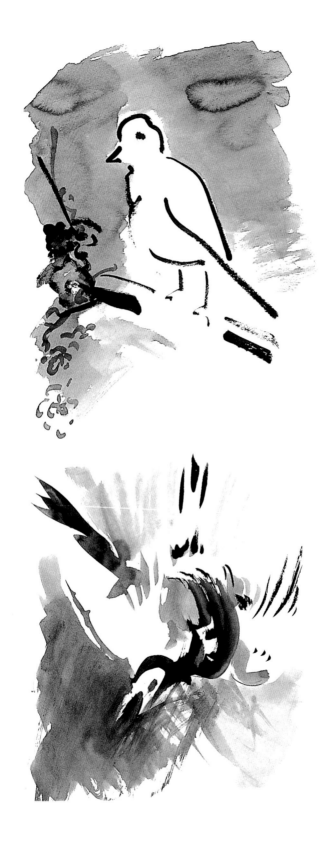

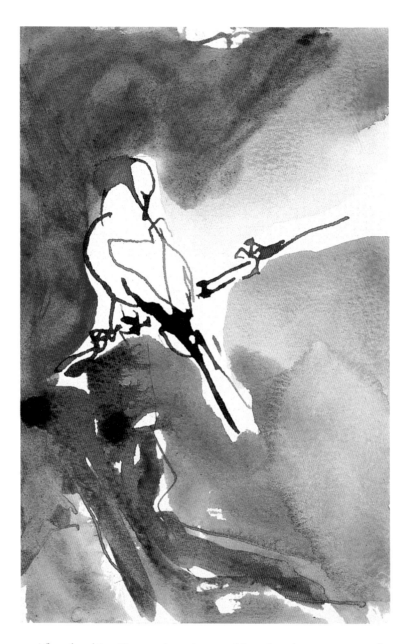

After sketching Conway in various positions, I took my memory of working with him, together with my drawings, to my studio, where I painted studies of him in watercolor, in mixed media, on white-paper ground, and on toned ground. Since he was white with exceptionally dark brown eyes, toning helped to bring his body into relief on my paper, without my having to resort to outline.

Conway certainly was cute enough to keep my attention for a while as an artistic subject, and I did have caring feelings for him, but I could

not get a series of finished paintings going that pleased me. Perhaps cute was not enough for me. When I finally captured an image of Conway that I liked, I felt pressure to move along to another animal. Since I didn't have other pets, I went to the zoo and was soon well into a series of watercolor sketches of macaque monkeys.

As I was working, some geese that shared space with the monkeys started making a racket, fighting incessantly. Normally, these geese swim around a rocky center island where the monkeys spend their time, occasionally going after food or a play stick thrown in the pond.

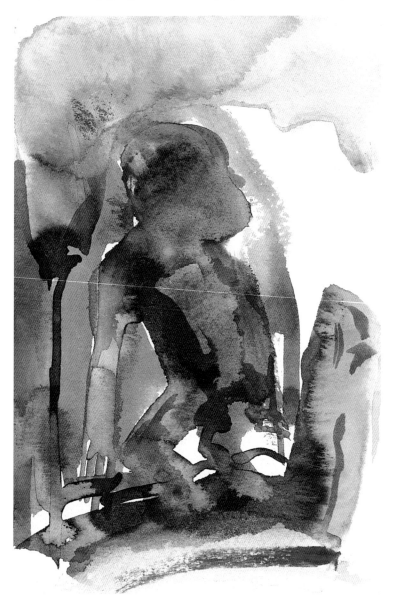

But the monkeys do so reluctantly, staying in the water only long enough to retrieve an object, submerging as little of their body as possible while keeping their heads above water as they awkwardly dog-paddle around.

So you can imagine my surprise when one of the larger monkeys *dove* into the water from the rock, right into the midst of the noisy geese. The shock quieted the geese, stopped their quarreling, and sent them scattering. Mission accomplished, the totally wet monkey, as if pulled in like a yo-yo on a string, immediately jumped out of the pond, vigorously shook the water off its fur, and stood—satisfied that quiet had once again been established in the neighborhood. The geese had posed no threat at all to the monkey, who seemed to be responding only to their noise, which the monkey evidently wanted to put a stop to, and did.

But this incident, however memorable, and other fascinating events I observed that day at the zoo, did not yield me any artwork, possibly because it left no problems to be solved. I had to search further. Perhaps studying how other artists were inspired by animals would help, so I visited museums. I studied Henri Rousseau's lion in *The Sleeping Gypsy*. What an intelligent and benign animal it is. So unlike Rembrandt's drawing of a lion which, though resting, looks more capable of violence than Rousseau's lion does while standing. I loved the lions and other animals featured in the great art I saw that day, but for the animal paintings I wanted to create, I still had not found the inspiration I needed. So I turned inward, to my imagination.

I thought: *What kind of animal would I like to be?* A bird—to fly? A dove, like the ones Matisse and Picasso painted? I drew doves. Again, I developed no body of work.

Then, unexpectedly, I leafed through a library book in my studio. There was a small reproduction of a fifteenth-century print of an owl. I can't even find it anymore, that's how insignificant it seemed at first. It was not as great a work of art as Rousseau's lion, but I was soon hooked on owls. I immediately did a drawing in black charcoal with some pastel. Then I reached for my black paint and ink; next, for brown paint and ink. My improvised owl studies kept growing, and since my watercolor palette is always set up, I added some colors to the brown and black paintings. Next, I painted owls in a broader spectrum of color. I did large owls as well as smaller ones. I tried mixed media— adding casein and crayon marks, even collage. My owls became more human in feeling and more abstract in shape.

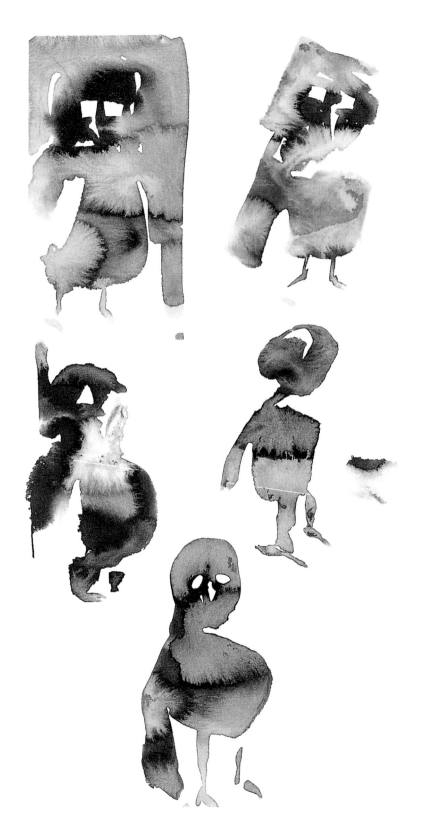

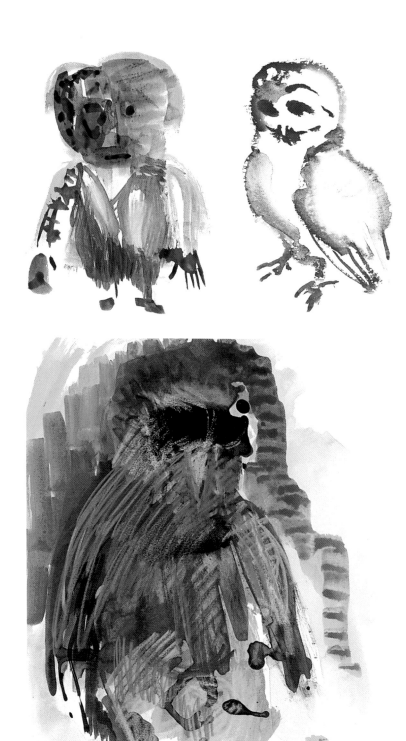

I went to the natural history museum and drew owls. Then I sketched the few owls kept at the zoo. To learn how the relationship between person and owl can progress, I read whatever I could get my hands on, devouring nonfiction descriptions by people who had found young owls and gotten permission to raise them. Then a fictionalized account from the point of view of an owl described how he was captured to be used as a decoy for other birds during the day. Although at night other birds—especially smaller ones—fear owls, during the day they feel free to attack an owl that is out in the open. So, if trained to stay in place during daylight, an owl will attract birds that can then be

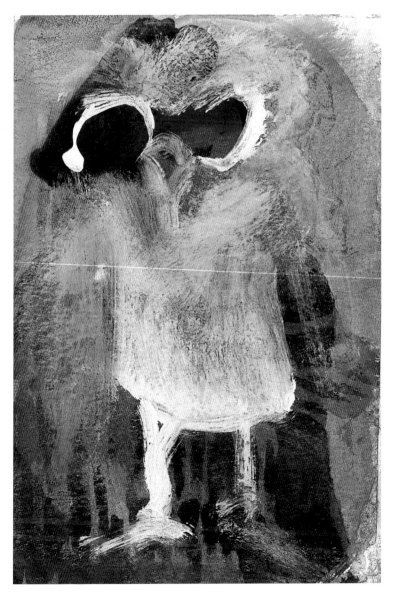

bagged by hunters waiting in ambush for them. The novel's theme was about freedom—the owl's freedom. As the plot evolved, the owl was unpredictably set free and returned to his cave and former life in the wild, with much trepidation and physical difficulty along the way. But despite his troubles, he flew silently and long, and was free. Perhaps there was some of that owl in me.

Before I knew it, I had hundreds of images. A year had passed without my losing the capacity to generate work built on seeing one old and unremarkable reproduction of a print of an owl that I can no longer even find. It wasn't a living owl that captured me; it wasn't a

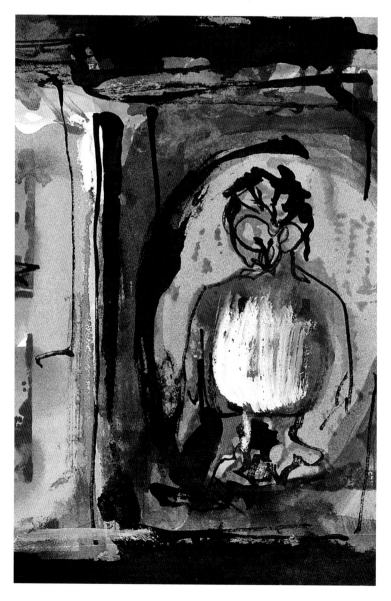

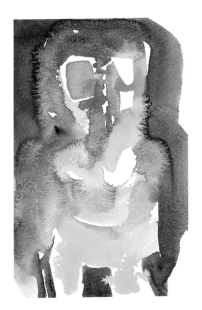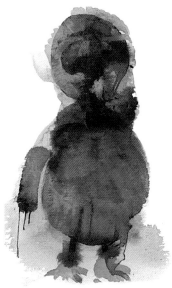

fine painting of an owl; it wasn't even a good reproduction of that fifteenth-century engraving; no, it was simply an ordinary print stumbled upon in a now-forgotten book.

I was still painting owls when I had a chance to visit an urban stable where a friend worked. Never having been to a stable before, I jumped at the opportunity to be close to the horses, and took along so many carrots and apples, I could hardly carry them. I fed each and every horse there and had a wonderful time, but as soon as I left, I got sick. I couldn't stop coughing, felt miserable, and feared that I might be allergic to horses.

When the problem did not resolve itself, I was tested. No, I was not allergic to horses, but to the mold that grew on the hay fed to them and used to line the floor of their stalls. While I felt emotionally more comfortable with the idea that I was allergic to mold rather than to the elegant, large animals, I still couldn't go back to the stable again.

Coughing long and hard, I had to find and protect myself from other possible sources of mold. So I removed the industrial carpet in my studio on the chance that—with all my watercolor drippings—it might be getting moldy, too. The studio opened up visually as soon as I removed the gray carpet. Under my feet now were old, beige-colored asphalt tiles. Although the room was less attractive without the carpet, it looked more like a workplace. I loved the studio that way. It was clean, and I could work more "cleanly" in that environment.

But horses remained on my mind. Still coughing and taking my medicine, I "saw" horses all around me. Carl Jung says that an artist's

strong preoccupation makes strong art. Well, I certainly had another strong preoccupation, thanks to my body's unmistakable reaction to the stable. So perhaps it was preoccupation that I needed, not just admiration for an animal, however cute, for the art to develop. I liked the monkeys at the zoo and the lions in paintings—but they produced no series of images for me, while the owls, and now horses, did.

I knew I didn't want to be a horse—after all, they couldn't fly. And being Pegasus wouldn't do; that wasn't real enough. I had to be a real animal, not a mythological one. I began finding horses everywhere. I drew them in the park—from a distance, studied pictures of

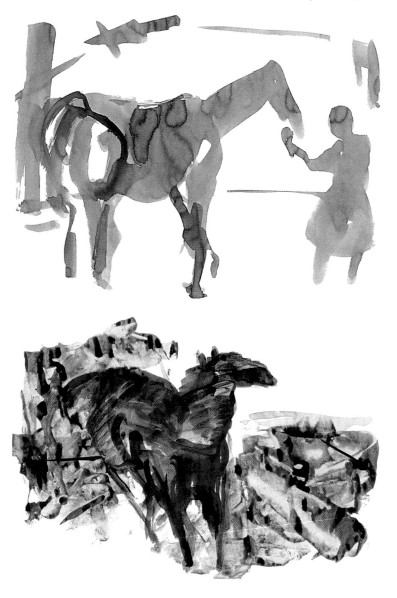

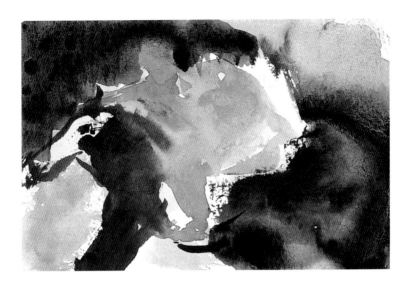

them in books. Finally, I got so tired thinking about horses all the time, I began to paint them in my studio from memory, again, first in black paint and ink and then in color.

I found that I needed more substance, a thicker paint, to say what I wanted to say about horses, so I brought jars of egg yolks to my studio—yolks that ordinarily I would discard once I had used the egg whites in cooking. I mixed the yolks with water-based paint and loosely applied the blend to my paper, changing the texture of the paint mixture by varying the proportion of yolk to paint. The more yolk used in proportion to paint and water, the stiffer the mixture became and the more it held its shape. However, it was greasier, too—so greasy that oil from the yolks worked its way through to the other side of my paper. But I soon found the right mixture and created a number of paintings using different colors, as well as the different textures.

My horse paintings kept coming. I made a large, densely painted watercolor—pure watercolor this time—of a partial sideview of a horse with his back to the viewer. Layer after layer of watercolor produced an opacity that contrasted with the light and thinly painted tints of the underlying white paper in other areas. That horse pleased me.

When I recovered physically, I suddenly stopped making images of horses. My preoccupation with them was gone; the impetus that drove the work just disappeared, and I knew that I could not force it.

Now I had to wait until I found my next preoccupation. My search began again to discover my next work passion. Would it come to me through another animal? By now I saw myself in many animals. My search reopened.

A p p r o a c h e s

Living creatures are not just observed; they interact with us as we inter-
act with them and with our artwork. In effect, we are in a situation and
observing it at the same time as an involved participant, not as a detached
observer. Such interactions can be recorded in several ways through
your art. Here are some approaches to try.

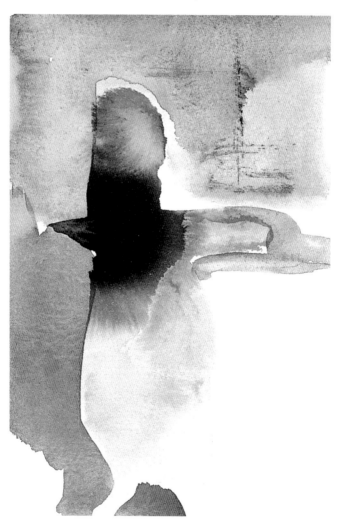

Do you have a pet? If not, maybe you see a friend's or neighbor's pet often? Perhaps you have caring, positive feelings about it, as I did about my canary—or you may strongly dislike or fear the animal. Whatever your preoccupation, if it is a strong one, it has a chance of sustaining your interest as a subject for painting.

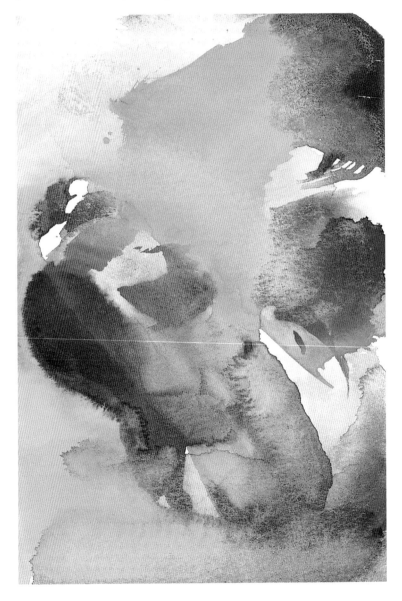

AN ANIMAL YOU'D LIKE TO BE

Which animal would you like to be? Perhaps more than one? All animals have their crucial place in nature's order and balance of things, so whichever animal you find will be an important one, with good qualities as well as some less desirable ones. I found that canaries are wonderful, but they are fragile. Owls are strong, but have almost no sense of smell. Horses are beautiful, but they are vulnerable in spite of their size, they choke easily, and their thin legs are readily injured. Whatever its qualities may be, the animal that engages your interest has a good chance of generating your art.

AN ANIMAL SIMILAR TO YOU

Consider the animal you really are like, as opposed to the one you would like to be. Think hard about it, and it may come as a surprise that the two are not necessarily the same. The animal you are (is it the one others see in you?) may be more humble than you thought, or grander than you thought. Whichever qualities it possesses, that animal is, by definition, important in the order of things, and could provide an important link to your art.

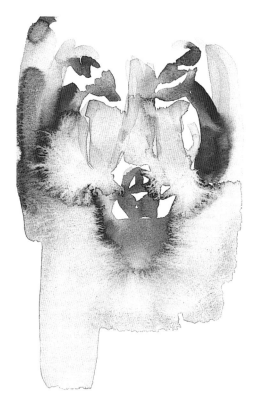

You may come to see yourself in many animals, or even in all animals. It is not only Buddhists who embrace that view. Western scientific research examines the complexities of animal behavior and repeatedly demonstrates the striking parallels between the behavior of human beings and other animals. Maybe you can bring that concept into your art by putting more than one animal in a painting. The pictures need not all be portraits, in the sense of having a single focused subject. Think of the powerful paintings of Frida Kahlo with a monkey. Can you paint the connection of person to animal?

SUMMARY: SEE HOW YOUR WORK DEVELOPS

I learned that "cute" subjects were not motivating enough to permit me to develop a body of work, although a simple image of an owl was. Pay attention to what captures your interest—without worrying about whether it is noble or a "suitable" subject for art—and draw it, paint it. Your work will tell you which way to turn for subject matter.

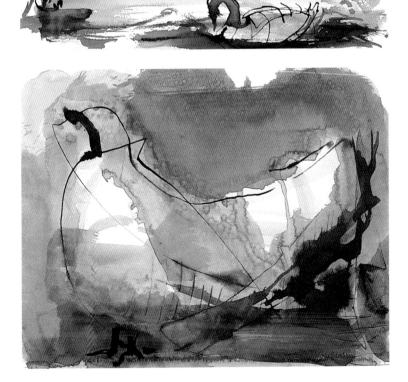

Observing and Being Observed

The Other Person

If I think *life*, I think *people*. So another person is a natural subject for me. If that person, the model, can stay a bit still, it helps.

While studying for a master's degree in painting, we all worked in a large atelier with enough space, but no individual partitions. Two models posed, seven hours a day, five days a week. Although models stayed put, we could move around. And some other students did, looking for the "best" view. They searched for it outside of themselves, in the model, in the environment surrounding the model.

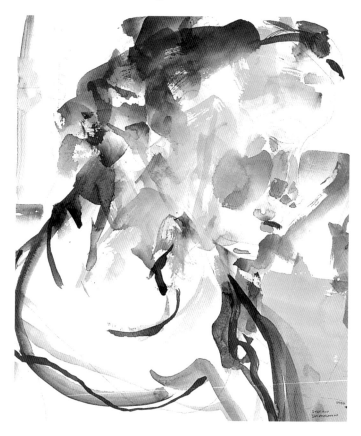

But I stayed in one place—a warm spot in the drafty room, close to the door, so I could take a break whenever I needed to without disturbing the others. I chose to paint whatever pose the model struck vis-à-vis where my easel was set up. To me, the human body is fascinating in all poses. Then, from my place in that large room, I searched—not outside but within myself—for answers to questions on composition, and for solutions to drawing views of the model convincingly.

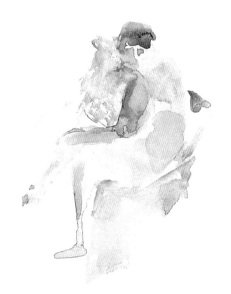

I had learned, by staying in one spot, that the model always returned to a comfortable position, and that each model had only a few comfortable positions. So I looked and waited before beginning to draw, waited until the model had settled in like a cat about to take a nap. Once the pose was established, the model was likely to return to that

position, even after straying from it occasionally. Those comfortable poses, the natural ones for each model, were characteristic of the person's personality and expressed the likeness, even when the face of the model was not in my view. The back of a person is just as distinctive and revealing as any other part when accurately perceived.

I believe that "seeing" comes from inside myself in relation to the model. If I needed more distance from the model in my painting, I didn't get farther away; I simply recomposed the work to include more of the

surround. To move in closer, I focused on a detail: the head, a hand, a foot, or even an ear. Paintings might stray from reality in color, in form, in likeness. As long as they worked, it was not a problem. But a weak drawing—one that bored me—was a problem until I found a way of making it interesting to me. Only then, could it affect others.

Working in a confined space has stood me in good stead over the years. Before having my own studio, I painted in my living room, on a remnant rug that visually separated off a portion of the room from the rest. The rug not only sectored the room, it protected the floor from spills, which could have been inhibiting. I became accustomed to some confinement. And, if art historian Ernst Hans Gombrich was right when he wrote that art comes from limitations—that without limitations there is no art—then I work well with spatial limitations.

Later, when I had my small studio and a model posed there, I was prepared for working in a limited space. My studio contains an easel, a drawing table, and a couple of chairs, that's all. Although I could not view the entire figure in one glance, I painted what I could see, mainly heads and torsos. But portraits of whom, doing what? Both questions resolved themselves quickly and easily. A colleague recommended someone to pose for me who was "the greatest." The model, a graduate student in literature, wove me into her busy schedule.

She really was a great model. Waiting for her to strike up her favored poses, I saw that she liked to read. Sharing her love of books, I suggested that she read while posing. Her positions never looked like "poses"— they were real stances, and as she assumed them so naturally, I became increasingly sensitive to subtle changes in her mood and attitude, which I exaggerated in my paintings.

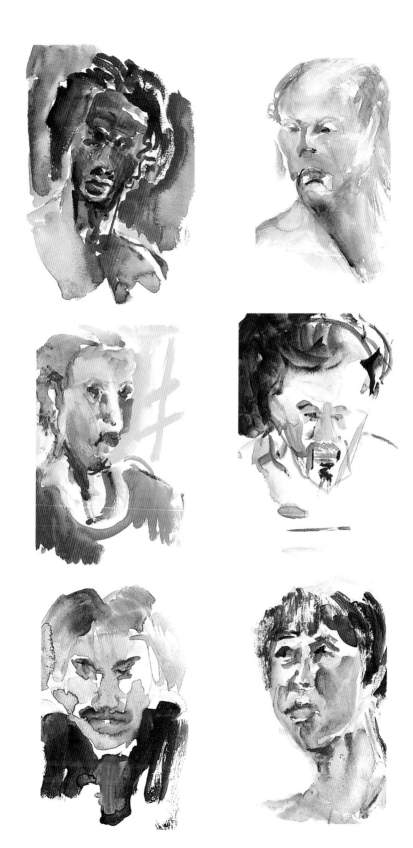

For an entire year, while she read or just thought about her reading, I painted. Her five or six natural poses that were comfortable in my small studio inspired numerous images over that period. She wore whatever she chose to, and although items of clothing might differ from day to day, her look varied little. I made hundreds of fresh images. Working with her in my studio provided high points in my creative process. When she wasn't there, I painted her image from memory.

In such close proximity to the model, an intelligent, observant other, I not only observed her—she watched me, too. She observed my facial expressions as I worked, and if she looked at my paintings in process when they were naturally in her view, she occasionally commented on them in a positive way. One day, this observing/observed state recalled a story I had read that offered a thought-provoking parallel.

I remembered an account about a scientist who had studied wolves from a good vantage point for weeks, but on the day his cameras were set to film them, he saw no wolves at all. Hours later, confused and disappointed, he turned to pack up his gear. Then he saw all the wolves in a row behind him, comfortably resting, watching him. Had they delib-

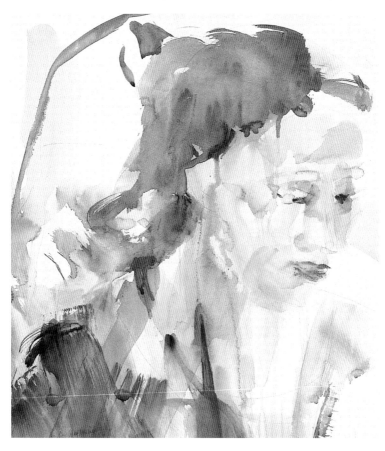

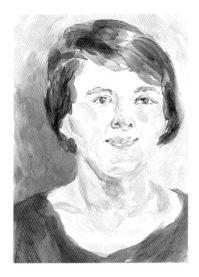
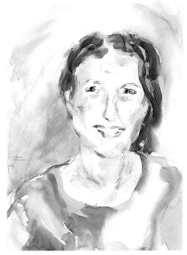

erately turned the tables on him? How dare they! *He* was supposed to
be the observer—not *them*.

Working with a model was made easier by my earlier student experi-
ence under scrutiny at the atelier, where teachers might appear at any
moment. Other students could also see what I was doing, and I saw
their work progress, too. I observed what happened when they changed
an oil-painted form in the center of a canvas from green to a sunny yel-
low—how changing one part could transform an entire painting.

I was also used to drawing in public. Through appointments made
in advance, many museums graciously allowed students to paint in
front of great artworks. Permission usually stipulated how far from the
works we could position ourselves; that our copies would be painted in
a size different from the original; and that we didn't block traffic of
other visitors. Some museumgoers glanced at my work, others watched
for long periods of time, and children stood quietly entranced. I could
see that they wanted to go home and paint, to make globs of paint take
on recognizable form on a canvas—like magic. Children brought posi-
tive energy. Happily, most onlookers said nothing. But when adults
chastised their children, or attempted to chat with me as I worked, that
could be jarring.

But to have others watch while I worked did help me learn to look
my mistakes straight in the eye. That's why I draw in black ink. I do
work in pencil and charcoal occasionally, but I find I am tempted to
allow myself to "settle" for an edge in those readily erasable media. Ink
won't allow that—and neither does watercolor—which is part of what
I love about it. When I first drew with black ballpoint pen, any error
glared at me. It couldn't go away! But it gave me an anchor on which to

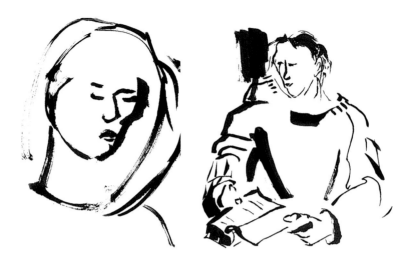

hang the next—more accurate—line or form on that same surface. Ink helped me learn where correct forms were. To my surprise, the "mistake" lines when left in place strengthened my drawings. I came to see drawing as a search, and each mark as part of that search. More than any teacher, ink taught me to draw.

Working in watercolor—risking a mistake that is irreparable, knowing just where the line is, the mark is, and whether it is right or wrong—is generous in its feedback. With a readily changeable medium, you can get it right, but it's also possible to continue to miss the image because of the ambiguity of edges. And it is the edges that determine the accuracy of the form—the power of that drawing or watercolor.

One decision I didn't anticipate was whether or not to talk while working with a model. In a group, people usually work silently and do not speak to the model, except perhaps during the break and probably not even then. That avoids the din of everyone talking at once. But working alone with a model provides more flexibility. Some artists talk nonstop as they work—a monologue about their work, about themselves, about anything that focuses their energy on painting. Other artists find that the model is more natural and less bored when talking, often with the self-revelation of an encounter between strangers, while the artist can concentrate on working.

But when I worked with my model and she read, there was silence. When she was tired reading, she might talk about what she'd just read, and react to it. That, too, entered the painting, or even stopped it sometimes. We came to understand each other better. I found that periods of intense concentration on my work interspersed by good talks about what we were thinking at that moment helped us both, she with her reading and me with my images. It solidified a working relationship

that spanned a year. Even though we don't see each other often now, when we do meet, we pick up where we left off—somewhere in the discussion of eighteenth-century literature.

Once, after being up all night doing a term paper, my model fell asleep in her chair. I painted that. I always followed her lead. She read, thought, rested, laughed, and I felt relaxed enough to make images of it all. For us, getting to know each other was natural and more comfortable than silence.

What I seek in my work is sincerity in the immediacy of the moment. You can argue that sincerity is not enough—and I agree—but without it, there is no art. Children's work is moving and interesting, because they are genuinely involved in what they are painting and drawing. They succeed in communicating with us, even when they don't have technical skills. Whether children's work is "art" or not is a philosophical issue we will not solve here, but it does communicate.

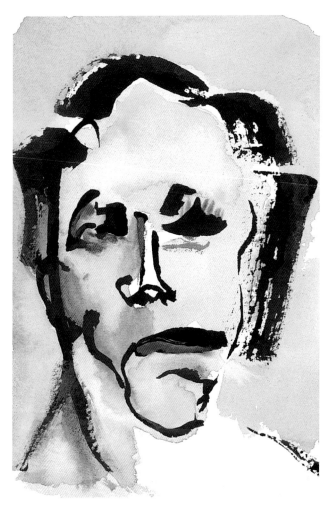

A p p r o a c h e s

Regardless of the current subject of my watercolor paintings, I work weekly from figure models just to keep my hand trained. Like any skill, unless it is kept up, it fades. Here are some ways that you might make life drawing a part of your ongoing development as a watercolorist.

JOIN A LIFE CLASS

If you haven't already joined a life class or worked in a group with human models (even in small towns I've always found one), then you have an important experience ahead of you. Whether you love it or not, whether you decide to paint people or not, there is much to be learned in a group, for it offers the opportunity of seeing how others work—observing changes in their paintings (not by standing over them but from across the room) as they develop a composition and plot out their colors.

Some artists feel that working with nude models is essential for learning the structure of an individual human form. Others find clothed models to be just as informative for figure studies. For me, the important thing is to draw and paint the live human form, whether clothed or not.

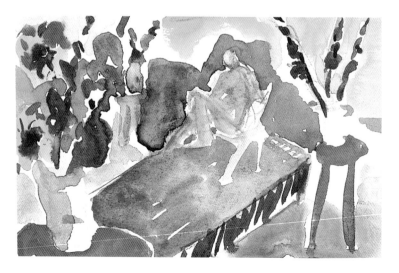

FIND A MODEL

Ask a friend to pose for you in whatever she chooses, even her baseball uniform or her wedding dress, which she just found in the closet and miraculously still fits. Whether it's a friend or a hired professional model who poses for you, expect that some models are easier to paint than others. Even when people agree to pose as a favor, or make a living doing it, some models are obviously more comfortable being observed, scrutinized, and interpreted by you in your painting than are others.

POSES AND PROPS

If you have the opportunity to decide on the pose and determine what the model rests on, which chair, which stool, which color cloth is draped on the chair if you choose any drape at all—you can learn from that. If you're painting with others, no single pose will please everyone in a group, but if you hear what they do like and what they don't like, you'll find your kindred spirits for next time.

SUMMARY: OUR ART SPEAKS FOR US

After repeated forays in the direction of other subjects, I have always returned to painting people. I carry back what I have learned elsewhere to my work with human beings, or I come to see various subjects in the context of—or as extensions of—people. I probably can neither change that nor did I consciously create it. Another artist may speak through gears and bridges or find that boats say it all. But independent of subject matter, artists communicate their thoughts and emotions about the world and themselves to us, to the other person.

Some images are painfully battled through in paint on the support surface; others joyously flow already formed from the beginning, sometimes outside of and below the artist's level of awareness. Either can produce great art. Transcendent moments in art—whether attained through joy or through struggle—show in work that jumps out as sincere, as communicating feeling. And when generation after generation still interact with a work, it was probably created in moments of transcendence. Those moments cannot be willed. Instead, it is about *letting go,* giving permission to our skills, training, and hard work to be the best that they can be, and trusting in what emerges from that—whether it is appreciated in our lifetime or not.

IT'S IN THE DETAILS

Childhood Memory

Reflecting on childhood memories can conjure up a wealth of imagery for an artist.

When I was a child, my neighborhood was not stylish. But we had central heating and a full bathroom. My friend down the block had only a potbelly coal stove and bathtub in her kitchen.

City summers were hot and humid. On especially sticky days, I remember pulling a straight-back chair as close to the window as possible, then draping my bare feet out over the windowsill, putting them right up against the curved metal window guards which had been installed to keep children from falling out.

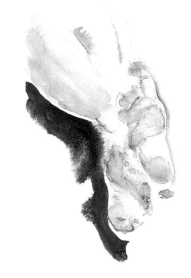

One afternoon in particular, when the temperature was 104 degrees outside and probably higher inside, I stuck my feet out the window. At six years old, I was convinced that if I could only catch a little breeze on my bare feet, then I might not explode from the heat. A sensitive child, I could feel the slightest movement of air over my body, savoring it and getting a full, though momentary, benefit from it. Each puff of air brought hope that it would not always be so hot. That day was the highest temperature I had ever heard of. Everyone talked about it.

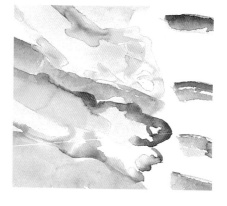

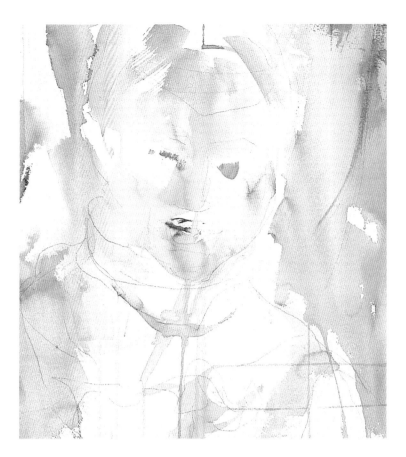

Two weeks of heat in the nineties, and that day it got even worse. Would the temperature just go up and up? Would we all be cooked?

At that time, even wealthy people didn't have air conditioners, but a few movie houses were "air cooled." That system was uncomfortable in a chilly way—damp and clammy, much as I imagined sitting in our refrigerator would be.We did have a refrigerator at home—unlike my friend's home where ice was delivered daily for their "ice box" (literally a wooden box with two compartments: one for a block of ice with a drip pan beneath, and the other for foods to be kept chilled).

Since our refrigerator had no ice-cube compartment, I dampened a washcloth with cool water from the tap. For a moment the cloth felt good on my forehead, but then it got warm and sticky just like everything else. As I got more and more uncomfortable, I tried to read. The book alternately rested on a corner of the chair, or on my lap, feeling like a woolen blanket over my knees. Shifting my weight on the hard wooden chair, I sought a comfortable place for my calves on the windowsill, and for my feet either on or against the metal window guard. Sitting this way took all my energy for what seemed like hours.

Then I noticed the sky turning from its pinky-gray haze to yellowish. Could it get hotter? Suddenly, there was a real breeze—lasting for several seconds. Then another breeze, as the sky got yellower. I felt a drop of water on one shin. Was the neighbor upstairs watering her plants? Then another drop. The sky got even grayer and more yellow; it was almost green. Another drop and then it was raining—lightly, tenderly tapping my toes.

Lightning and thunder brought more rain. The heat spell was broken. One very hot spell each summer—that's what people said—and this one had just ended. I was calmer, much calmer—my discomfort washed away by water falling from a yellow-gray sky. I jumped off the chair, ran downstairs to the sidewalk, and stood in the rain.

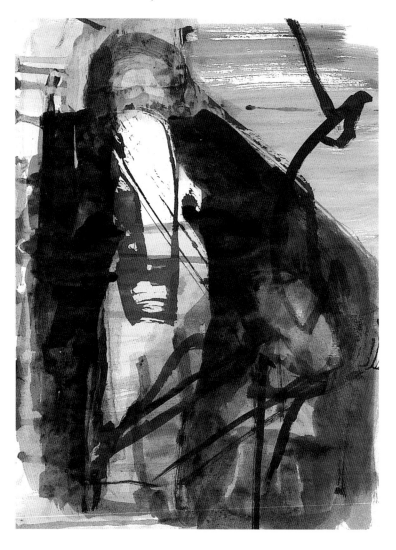

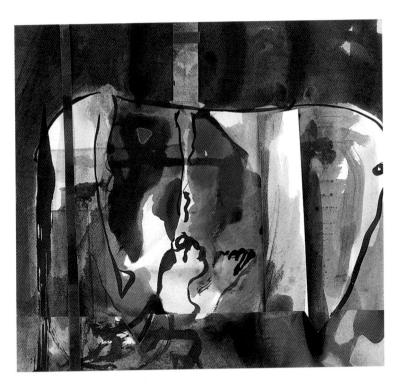

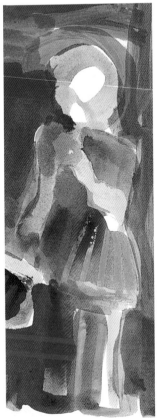

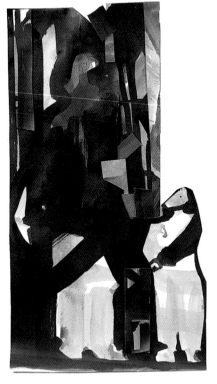

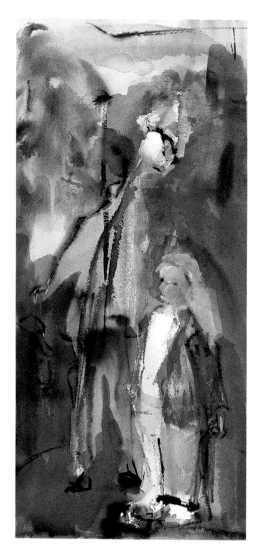

When painting a childhood memory, I chose the experience of that panicky and uncomfortable six-year-old. I chose to paint the growing breeze, the yellowing sky, and the wonderful cooling rain—to paint the blessed relief from being painfully hot.

But memories are fickle. What actually happened that day? How much is elaboration of my skeletal memory? There's no way to answer that fully. Mostly, though, I rely on feelings. I trust not just emotional feelings but my memory of physical sensations of heat, pressure on my lower back, on my legs—the experience of my tender, young toes on the rough, rusty metal grating of the window guard. These are sensory memories. Other details—the title of the book I tried to read, what I wore, what we ate for dinner that night—are lost.

The taste of a madeleine cookie set off Marcel Proust's powerful writings of his memories. I, too, have come to trust my bodily sensations, both as repositories of memories of my past and as a source of rich material for my paintings.

Another way of recapturing past images is from old photos. One in particular has been a rich source of images for me. This black-and-white photograph—printed on thick, grainy paper in varied shades of pearly grays—shows me standing next to my father. I am holding something tiny between the thumb and index finger of my right hand. I believe I

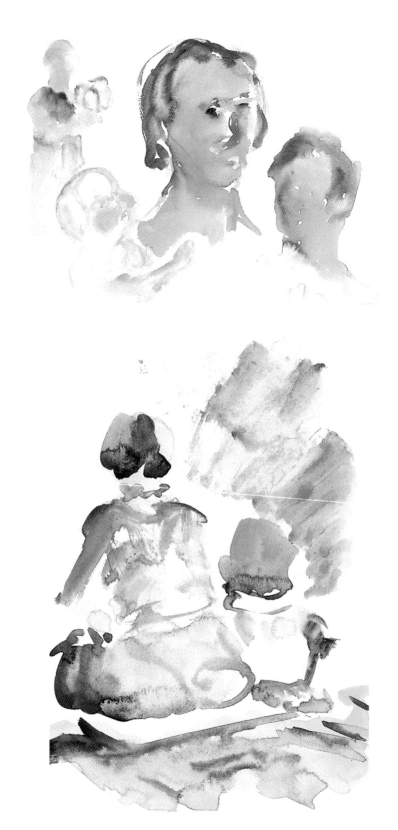

had found a pebble, and held it between my fingers. My father was probably concerned that I would put it in my mouth and swallow it accidentally. But I don't look as if I had any intention of putting it in my mouth. It was my treasure. It was going home with me and would reside in my pocket or go right into my turtle bowl with store-bought pebbles. But this was *my* pebble. I had found it; no one was taking it away from me, not even my beloved father, and not even for the best of reasons.

Which part of my interpretation is in the photo, and which is reconstructed from memory or logic? If my father were alive, I could ask him—that is, see if he remembered a moment which may not have been important to him, although it was to me.

We believe memories are accurate. However, differing eyewitness accounts remind us that what even intelligent, well-meaning adults remember can vary a great deal. But from a psychological point of view, memories are "true" even when they have nothing to do with "reality" from another person's point of view. The more we retell our memories to ourselves or to others—in images or in words— the more our stories solidify in form. We gradually lose touch

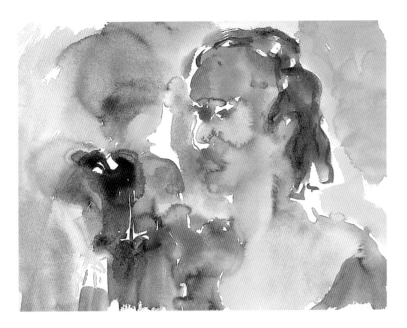

with what we "knew" about what actually happened. In its place we remember our transformed versions—often simplified or cleaned-up. These become the preferred versions of events rather than those composed of complex, messy, or unpalatable facts.

Why say so much about apparently insignificant events? Why indeed? Perhaps because life and art are precisely in the details. Things that have actually happened, and our reconstruction of them and their place in our life, determine what we feel, what structure our work takes, and what images we make. Think about it. What does knowing one person or one subject area more deeply than another *mean*? The answer jumps out at us: We know that person or subject in detail—important details.

For the painter, details are important. For example, if you are out of ultramarine blue and you know that you will need that color to take your work to the next step, then no other color will do. That is no insignificant detail; it is essential to the completion of your painting. However, when you are searching for—but uncertain about—that next step, then substituting another color, say cobalt blue, cerulean blue, or even violet could open up a new way of seeing your image.

You, as the artist, have to make that decision. The accuracy of such decisions distinguishes images that stay with us, as opposed to those that pass into oblivion. Images can crystallize events in memory. If we value the details in those images, we have a better chance of creating memorable pictures.

A p p r o a c h e s

Images activated by childhood memories can be brought into focus in many ways. Here are two approaches.

EXPLORE OLD PHOTOS

Look through your old family photographs, preferably ones that have not been "explained" to you many times as you were growing up. Stay with a photo that grabs you, and paint that experience, that moment, as you feel it from looking at the photograph. Then paint it a second time, and a third. Keep working with it as long as it stimulates your imagination. Now, number these memory paintings on the back so that you can recall the order of the series. You might even take snapshots of your paintings as you finish them to record their sequence.

When you've exhausted the image, wait a week and then look at your work—at the last image you did—and compare it to the photo that inspired it. Next, compare the very first image you painted to the photo. Then look at the first and last of your pictures in this series. How has painting the memory transformed the photo image? Or how has your memory changed over the series? Have you subconsciously formed the paintings more and more, so that they're closer to or further away from the original photo? Perhaps they resemble the photo in one way but not in another. If you place the series of pictures in front of you in the order that you painted them, are there any trends in the way the images develop?

SELECT A MEMORY

If you are still interested in painting your past, select a memory that you might like to paint—one for which you do not have a photograph. Paint it without worrying about the accuracy of your perspective or drawing for the moment. If you can, paint a series about your memory and view the paintings as a series again.

Regardless of whether you select pleasant memories or darker moments, if it ever gets too much for you—too uncomfortable to deal with—you can go to another subject, or dilute that subject with another subject that is emotionally easier to handle. But if you choose to see it through, you may find that the past event, however dark or difficult, has a positive side.

Sometimes the darkness you envisioned as being true when you were a child may no longer be true now. As in my case, recounted earlier in this chapter, what frightened me so much as a child—a very hot day—wouldn't threaten me as an adult, not only because technological advances allow me to turn on my air conditioner when it's hot, but also because as an adult, of course I am more able to look after myself.

SUMMARY: GROWING PROCESS

Some people find the past, and particularly their childhood, a rich source of material for their paintings, while others dislike looking back. The latter want only to be in the moment or to look to the future. Again, there is no one right source for images. Any source that works one day may be supplemented another day by a different source or given up entirely. I find that the process of growing—the gratification I get from my ability to change—makes me glad to get up in the morning to learn more about watercolor painting and about myself.

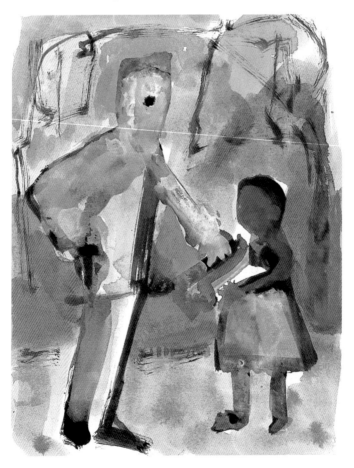

W H O A M I ?

S e l f - P o r t r a i t

In the previous chapter, I dealt with memories, exploring who I was as a child. But who am I today? Can I find out through painting? Rembrandt did, in his self-portraits. He painted images capturing himself as a carefree, cocky youth and then did portraits of his "down," but far from "out," face forty years later. Throughout his life he scrutinized his face and hands, accepted his mood, his stage of life, and his paintings got more and more powerful. He is the best example of the premise that the longer you paint, the better you get.

Cézanne's self-portraits, like those of Rembrandt, span his life. They range from heavily impastoed oil paintings of his youth to what I have come to see as the "essential Cézanne" in the watercolors of his old age. Cézanne referred to himself, in the year that he died, as the "pupil of Pissarro," saying that only then was he beginning to learn to paint. Although he had been working for over forty years when he said that, and had created numerous masterpieces by then, he genuinely felt that he was still finding his way, still had to grow. Many hold Cézanne in higher esteem than Pissarro (if the figures at auctions have any meaning), but Cézanne knew that Pissarro had something to teach him, and to the end, he was grateful.

Francis Bacon's self-portraits or those of Lucien Freud are dynamic examples of self-searching modern paintings. Why do artists continue to paint their own image in this age of disposable cameras and instant snapshots? Is it simply, as Bacon suggests, because there is no other model around at the time? Or are there other reasons, too?

Like Bacon, I paint images of myself when I'm stuck for a subject, but not simply because there is no one else to paint at that moment. I could hire a model, but I don't. Instead, I search for who I am at a given point in my life. To move on to my next phase of painting, I have to know the person I've become since painting my last self-portrait. Painting my own image points an arrow to where I am and where I am going. Some artists joke that "the price is right;" that it's cheaper to paint the self than to pay a model. But emotionally, painting the self is not cheap at all.

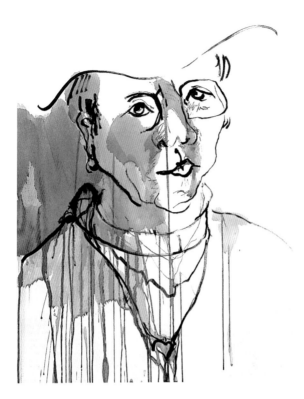

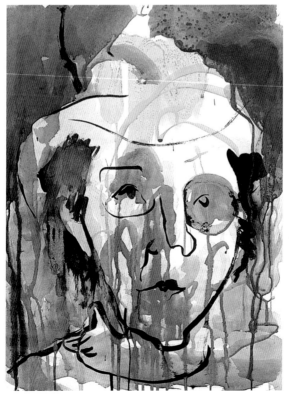

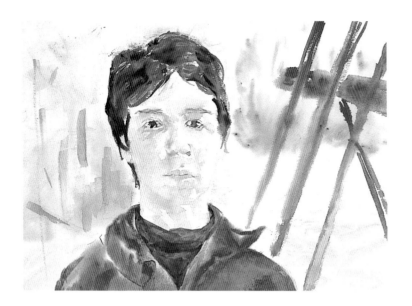

When I was a graduate student doing research for my doctoral dissertation on duplication of facial expressions, I asked people to imitate their own and others' facial expressions, as shown in photos put in front of them. Everyone found it harder than expected. I thought it would be simple, and I put this exercise into my experiment as a baseline so I could move on to my primary issue: the communication of emotional meaning through nonverbal cues such as facial expressions.

It turned out to be difficult for participants to duplicate facial expressions. It was not easy to look at a photo of oneself and then gaze into a mirror and make faces to emulate that photo. Some people found it impossible to look at their own facial expressions for any length of time. Although usually they didn't give up, one woman did, saying that she simply could not do it. But most people self-consciously guessed and approximated duplicating their own facial expressions. Those personal duplications were judged by a group to be worse than their duplication of others' facial expressions.

Yet, I had every reason to expect, beforehand, that the reverse would be true. After all, what is more familiar to each of us than our own face? For the volunteer subjects in my survey, the facial expressions were already in their behavioral repertoire; all they had to do was find and reproduce them. But they said that duplicating their own expressions made them anxious. As a result, the forerunner to my study became the focus of it. Duplicating their own facial expressions made people feel more anxious than duplicating others' facial expressions.

Maybe that's one of the reasons why painting self-portraits is not easy. It's difficult. First there are the technical problems. The model is

both subject and painter, repeatedly having to shift from the pose to make the next brushstroke. Going back and forth, from model to painter, is exhausting, physically as well as mentally. Is there a way to paint yourself without continually leaving the pose?

What about painting from a photo that you've taken of yourself? Bacon and other artists have worked successfully with photos. However, when some use "reference materials"—by which they often mean photos—they create stilted images that are readily identifiable as having the camera as their source. Perhaps they are afraid to depart from the already two-dimensional camera image—from what they think is "real." Then, no matter how good the photo is, the painting has trouble taking on its separate existence.

Another problem inherent to self-portraiture is the limited number of poses a person can get into while still being able to paint. You can only strain your neck so far to view your image in a mirror, or even in a system of mirrors. Full-face images, staring straight out at the viewer, can look confrontational. Other views, such as profile or three-quarter, are vulnerable to instability since each stroke of the brush pulls the artist out of the pose, and likeness is easily lost. Painting a constantly moving target may end up generalizing the image to the point where it doesn't look much like the artist or any specific person.

Although most people feel more comfortable with a portrait that is a likeness, I am not sure that likeness is essential. Likeness for the artist may be different from likeness for the viewer. The artist has a sense of what she looks like derived from subconscious elements informed by her own senses, including touch. The other person's point of view includes the artist's familiar stances. If we fool ourselves by thinking that we can look better with our head uplifted to shorten the appearance of a long nose—and that's not our usual stance—it won't be a likeness for the other person.

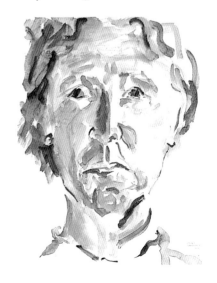

A self-portrait reflects who we are, what we have experienced, and how we view ourself. We cannot avoid it. And if we try to force some artificial view of the self, or of society's ideal onto the work, it weakens it and makes it less interesting.

Approaches

If you are interested in exploring self-portraiture, work simply and
focus your inner attention on who you are, rather than on what you
look like. Perhaps you will find that your likeness emerges without
your willing it. Or you may value your painting for what you've said in
paint—about yourself, your emotions, your understanding of being
alive. Here are some ways to find out.

NO MIRRORS

Without looking in a mirror, paint what you look like. Use any colors
or combination of them that you find useful, and don't judge or plan
what you are doing. Just work spontaneously. Set the painting aside
without examining it.

MONOCHROMATIC PORTRAIT

Work in one color only: black, ultramarine blue, an earth color like
burnt sienna, or any one single color that appeals to you. This time—
while looking in a mirror—paint a full-face self-portrait.

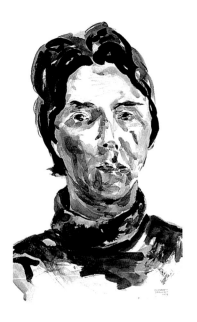 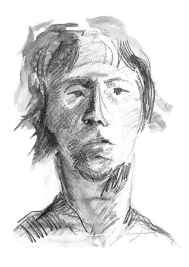

CHOOSE TWO COLORS

Use one reddish and one bluish color. Search for patterns of light and dark on your face as you look at your full-face mirror image.

THREE-QUARTER VIEW

Now that you've worked with your full-face image, you might want to try a three-quarter view, that is, with the whole of one cheek and part of the other showing, and your nose in partial profile. Choose whichever side you prefer. Some actors will present only one profile or three-quarter view to the camera, refusing to show the other side of their face on screen, because they so dislike its look from that angle. To see just how different the two sides of a face might be, try this experiment. Take two identical photos of a face and cut them in half vertically. Pair the two right sides, then pair the two left sides. You will probably find that neither the paired rights nor the paired lefts will be easily recognizable as the photo you started with.

SUMMARY: FROM THE INSIDE OUT

When you have exhausted your subject, take a look at what you've done. See which images look more like you as you see yourself, which ones capture the way you seem to others, and which ones are about the way you are inside. How we have come to see ourselves and the way we project ourselves to others can change over time, but not readily. And how we are perceived in portraiture at any point in our life rarely has to do with the exact shape of our facial features. Once we realize that the essence of self-portrait does not lie in perfect reproduction of physical traits, perhaps then we can make sense out of how a painting of a plain-looking old man, as Rembrandt was in his last self-portrait, can be so extraordinarily beautiful. That painting is not about the shape of his bulbous nose. It is about him, about us, about life, about paint. That nose—in that face—in that painting—becomes beautiful.

IS ART BEAUTIFUL?

F l o w e r

This is the hardest chapter for me to write. Maybe because flowers are the hardest subject for me to paint—harder than people. Not because they are more complicated. People are extraordinarily complex. Yet, I feel challenged by human complexity, not frozen by it. I had always expected people to be hard to draw, but I did not expect flowers to be. Perhaps I accept the individuality of the special, although flawed, nature of human beings. But it has taken me a long time to see that each blossom is an individual, too, different from all others, even on the same stalk or branch.

My problem with flowers is that they are so unequivocally beautiful. Even a wilted one, a partially crushed one, is beautiful to me. And the very thing that I love about them—their beauty—is their biggest draw-back to my understanding of them and to painting them. How dare I remake them? Can I show flowers in another way in watercolors, equally beautiful—but never more beautiful than they are to start with?

Flowers have a benevolent power over me. If I feel low or frightened, I look at a flower and I feel better. Whenever I have to give an important lecture or deal with a difficult situation, I walk where there are flowers.

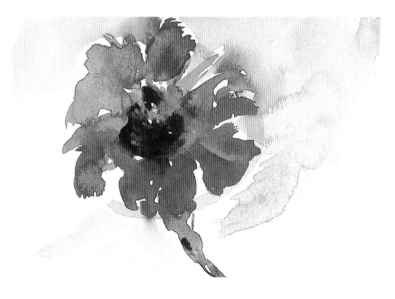

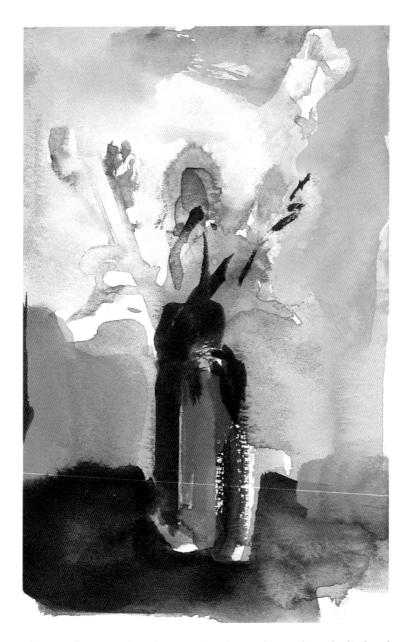

They may be tiny and on the ground in the tundra, or elegantly displayed in a flower shop, but each time I've looked for them, I've found them somewhere not very far away. If real ones are missing, there are always pictures. A Gauguin painting of a woman holding a flower was a great source of strength to me for years, and so is Rembrandt's painting of a woman holding a tiny "pink" in her outstretched hand.

Flowers heal me. Their existence and presence make me feel alive. You may not respond that way, especially if you are allergic to flowers

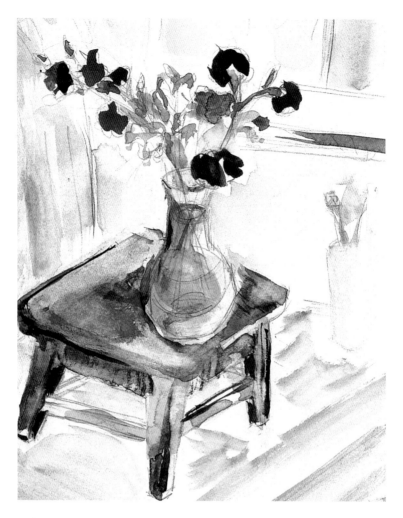

or have come to associate them with funerals. For you to evoke the kind of feelings I have for flowers, perhaps you would seek a sunset, a baby, clouds in the sky, or another sort of stimulus dear to you.

While it's not universal to love flowers, it isn't unusual, especially in harsh climates. On a trip to Iceland recently, I lunched at a wonderful restaurant that had many flowering plants on sills all along the completely windowed room. Long and dark winters there won't permit growing flowers outdoors, but indoors, diners year round see thriving plants and flowers of many species, all tenderly nursed by a fulltime caretaker. Although I had arrived past lunchtime, the staff kindly prepared a snack for me, and in the empty restaurant I watched that caretaker pinch a leaf or a bud here, mist some stems there, repot this one, and cut back that one. The radiant plants displayed the hours it took to care for them. Even species often seen alive but neglected in storefront windows were radiant in that Icelandic restaurant.

A similar episode that refreshes me whenever I think of it took place years ago in the northeastern mountains of the United States. In the middle of May, a wet, heavy snow fell for more than a day there. When it stopped and the sun came out, I saw a lilac bush in full bloom, laden with large globs of snow. It was breathtaking. The lilacs had survived the storm, although all the blossoms fell once the snow melted. That same wet snow killed the local pear crop, but the trees lived to bear fruit the following year.

How do flowers relate to watercolor painting? For me, painting beautiful things had raised the question: What is my justification for making an image that I know can never match the wonder of the original?

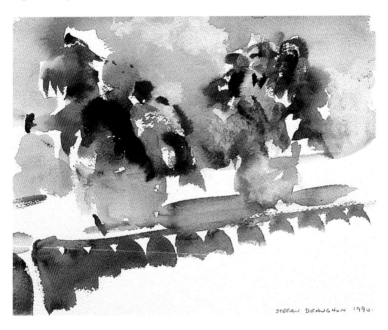

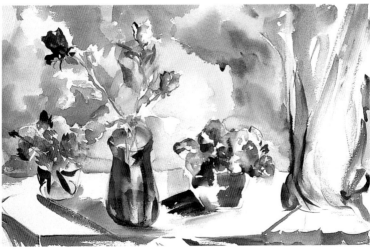

But once I understood that art is not about reproducing a subject in front of me, I could paint anything, even flowers.

There are many ways of depicting flowers. Traditional Chinese paintings of plum blossoms, for example, were often executed in black ink on white paper. Clearly, it is not chromatic color that draws me to such paintings—although plum blossom paintings sometimes do have a small amount of red and opaque white watercolor along with shades of black ink. It's that plum blossoms are not simply beautiful; they are also brave. They bloom in cold weather when other flowering plants would not think of putting out buds.

In addition to differing in color, shape, and scent, flowers differ in the characteristics we attribute to them. For example, since daisies are everywhere, does that make them "common"? Or "simple"? Or "pure"? Or all three, and more? Can the attributes we ascribe to flowers tell us anything about people? What if we saw people as the flower that best represents them?

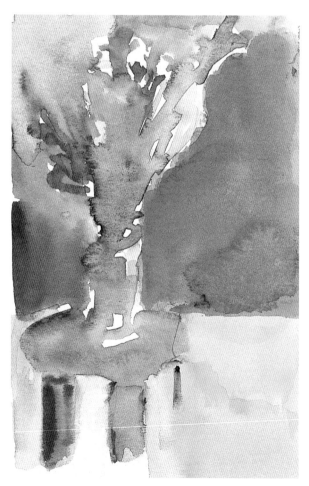

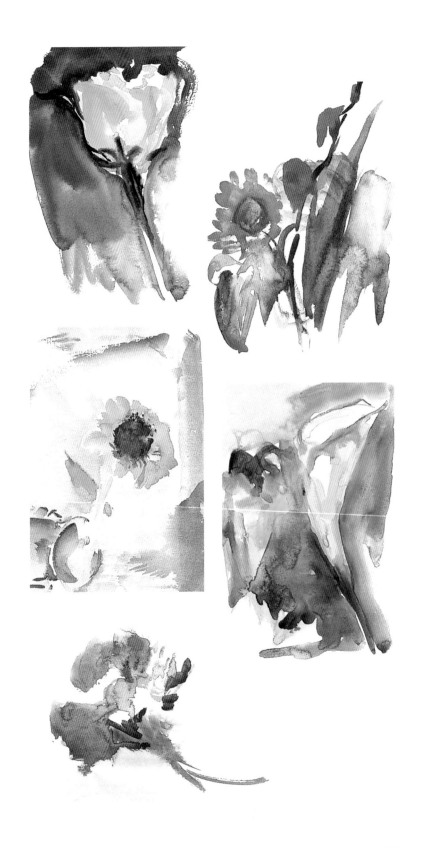

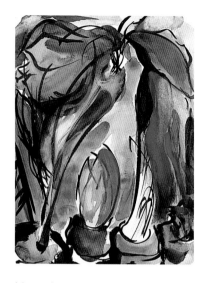

If you were a flower and not a human being, which flower would you be? What first comes to mind? Are you happy with your choice even after you've thought about it? Or is there a difference between the flower you see yourself as being, and the flower you would like to be?

When I playfully applied these ideas to myself, I was surprised that there was a difference between the flower that I felt I was, and the one that I would like to be. I am a carnation. I like carnations well enough, but they are not what I would like to be. I might prefer to be a peony. Its beauty is lush and full. Even one such flower fills a room, although once cut, it doesn't last long. Showy and perennial, loyal in their way, peonies return year after year to bloom their short season. How wonderful to have those qualities, to be like that!

But I am not. No, I am a carnation. I have come to appreciate carnations as I learned to value their characteristics in myself. Carnations are hardy, they have a long growing season—some bloom continuously and last a long time even after they've been cut. If cared for properly, every last bud will bloom, even in an apartment with little light. They are small, but their delicate scent makes their presence known. I am told that some varieties can even be used safely as a cooking spice, used like cloves. While few people would say that carnations are their favorite flower, I know of no one who hates them. So, on second thought, being a carnation isn't too bad. Not dazzling like the peony, but beautiful in its own way.

Then I wondered what flower my husband would be. We don't think of flowers in association with men in our culture, so I thought it would be hard to come up with one. But it wasn't. He is a chrysanthemum—a large, autumn-colored bloom that lasts and lasts, even after it's cut, and the plant blooms year after year. It is both an ancient flower and a regal one. In Japan, it is symbolic of an order, like a knighthood, with only male members.

At this point you might ask: If flowers remind us of people, why not simply paint another person or paint a self-portrait, instead of painting flowers? Why paint flowers at all? Because creating watercolor paintings

of flowers can be a shared experience that begins when you, the artist, react to nature, set that reaction in paint, and then activate in the viewer the feelings you had when beholding those flowers.

Flowers last a short time, but paintings can survive us. Knowing that reassures me when I'm tired or discouraged and wondering why I am there alone in my studio working to produce painting after painting. I paint for the search, the personal quest after self-understanding. But painting also bridges the gap between myself and others, between artist and community.

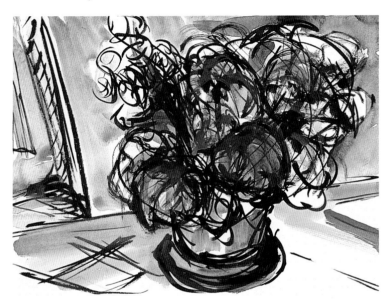

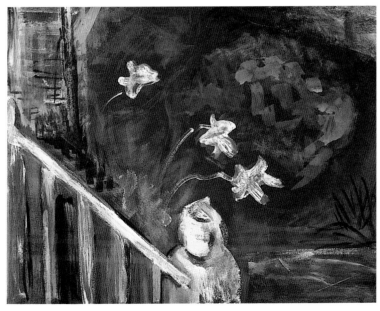

A p p r o a c h e s

Painting from nature refreshes me. See if it does the same for you when you try these approaches to painting flowers in watercolor.

FRESH-CUT FLOWERS

Most people enjoy working with fresh-cut flowers as subject matter for watercolor paintings. If you respond to flowers, they can become a life-long source of creative expression for you. Cut flowers are often just one element in a painting, shown in an indoor setting arranged in a vase or a glass, with other objects included in a still-life composition.

FLOWERING PLANTS

Some people believe that it is wrong to cut flowers, that they should be left in their natural surround, since cutting them ends their life pre-maturely. If you feel that way and do not choose to paint such dark feelings, or if you are simply interested in an alternate challenge, paint a green plant or a flowering plant. Still alive and growing, plants present an entire structure—leaves, stems, flowers, and the relationships of each part to the other and to the whole entity.

FLOWERING BUSHES AND TREES

Oriental flower painting is frequently set outdoors, featuring blossoms on the limbs of trees that seem to react to the fresh-air elements. They are not seen through a window from the warmth and safety of a home or studio (or an Icelandic restaurant, for that matter). As we look at them, we are right there with the flowers. We feel the sun, the gentle breeze or a storm, the warmth or the cold. Is that why such classic Oriental watercolors feel so alive, even though they are highly stylized paintings?

FLOWERS AS METAPHOR

Paint the flower you are inside. I saw myself as a carnation. But inside, on a deeper unconscious level, what if I am a plum blossom? What might you be like inside, in that part of your self that everyone does

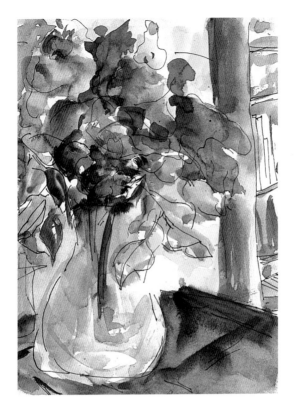

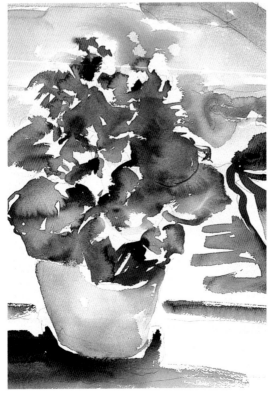

not see, yet which pervades your every action each day of your life? If you can do this playfully, while at the same time being open to learning something about yourself, then you may enjoy repeating this approach and painting the flower that someone near and dear to you might be. What about a parent? A friend? A lover? If you extend the list indefinitely to many others, would that tremendous variety in people lead you right back to painting flowers from nature, just as flowers?

Finally, try painting imaginary flowers. Odilon Redon created believable pastels of fanciful flowers in bunches emerging from vases. But you may discover, as many artists have, that it's more difficult to paint imaginary flowers than real ones—harder to make them believable.

SUMMARY: LOVE THE SEARCH

Each year, whatever else I paint, I also paint flowers. They come to life in my watercolors more frequently, but I keep searching for fresh ways to paint them.

I often think of Alberto Giacometti, who said he drew because he did not know how to draw. We think he drew well. But he knew that he only approached good drawing more and more closely. He was always dissatisfied—no matter how long he lived and worked.

In art, there is always more to learn and further to go. We approach an ideal, but never really get there. The closer we get, the higher the ideal. That pulls us forward to paint from previously untapped sources. I love that search; it is my passion, and watercolor is the medium of my passion.

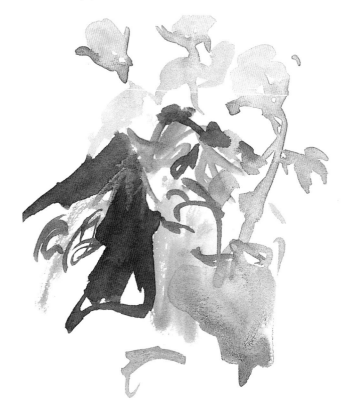

Making Contact

A Holy Place

I believe that deep inside the subconscious of each of us there is a holy place, and I think art comes from that place. Like happiness, we cannot find art directly. However, if we can make contact with our inner holy place, we increase our chances of making sincere work. By *sincere* I mean art that communicates directly from one person to another.

Since that holy place within is not easy to contact, we develop ways of getting there—of facilitating communication between levels of consciousness—allowing material from deep inside to percolate to more conscious levels of the mind. How can we make the unconscious in ourselves more preconscious, and then more conscious and increasingly within our control? In the case of watercolor art, by painting in different ways, having new experiences with painting approaches that may make tiny elements of the subconscious more available to our control as artists.

For some artists, their holy place connects to religious belief. We see that linkage in the work of Michelangelo in his Sistine Chapel ceiling. A believer, he was passionately absorbed in his work, devoting his enormous talent, skill, energy, intelligence, and determination to seeing his vision through to its monumental conclusion. Other famous examples of immortal works that must have come from holy places deep within are Chartres Cathedral, the enormous Buddha sculptures, the Dome of the Rock, the Cordoba Mosque, the Western Wall, and Stonehenge.

At this point we might ask: What makes artists think they have something to say to other people, often spending a lifetime communicating what they know to others through their work? I think artists—including you and me—have intuitions about the complexities of being human and living with other living things. If our intuition is wrong, then our work will probably not communicate with many others. But when it is right and the technical skills are there to place intuition in an aesthetic context, the result can be powerful and wonderfully moving.

The key word to understanding artistic sincerity is *intuitive*. Scientists systematically set out to prove hypotheses about the world, and they communicate to those who share an appreciation of their methods and of their understanding of probable truths.

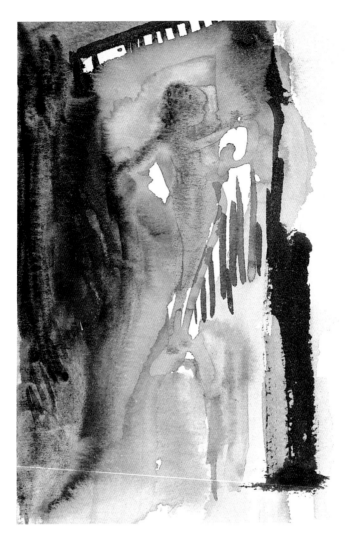

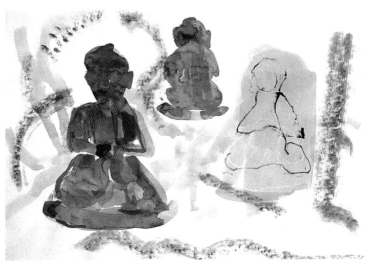

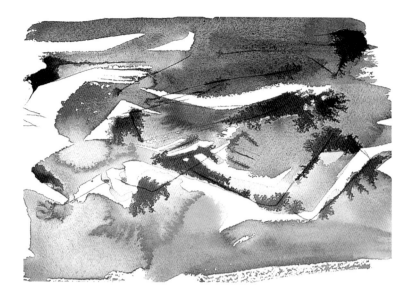

Artists, on the other hand, "prove," or demonstrate, simply by making a believable, persuasive image—an image that feels right to them and then to other people, too. A successful image cuts through our defenses right to the core of us. We don't have to think; we *know* the image is on target. Seeing it, we feel we have changed; we have had a new and different experience.

Since artists have potential power to move others toward their point of view, their work can have both positive and negative results. Artwork has been ridiculed, banned, and destroyed, surely not because it was innocuous, but because its consequences were feared. Sociopolitical forces with their own agenda often wish to control all sources of persuasive power, not leaving any in other hands—especially not in the hands of artists who might make unpredictable images that could be interpreted in unapproved ways. They and their work might look harmless and yet be socially devastating. On the other hand, artists whose work furthers the political, economic, or social goals that a society has set are often held in esteem and rewarded well monetarily.

The social position of artists might even be affected by the way they are perceived superficially. Working with paints can be messy, often giving artists the stained hands, soiled clothes, and rumpled look of manual laborers. To find the sensitive souls of artists, onlookers must see beyond dirty hands into the artist's searching eyes, for behind them reside those holy places from which art emerges.

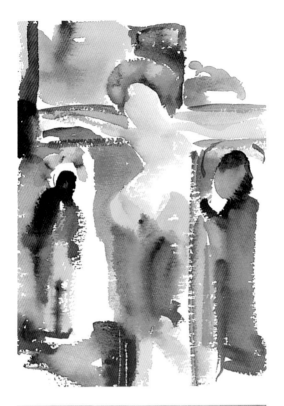

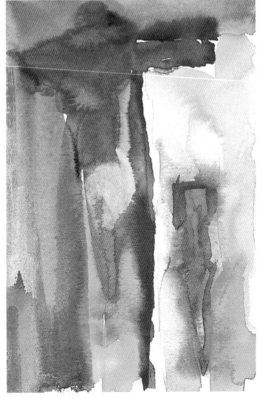

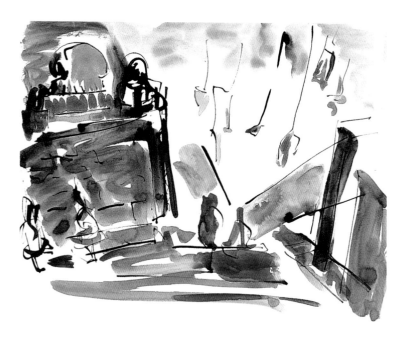

From the artist's point of view, doesn't it make sense to go ahead with work regardless of current acclaim or approval? This assumes that art satisfies our needs for discovery, for growth, for an enlarged understanding of the world.

So even when we can't achieve complete sincerity in our work, there is much to learn from the doing. Through touch, we get reality into our bones; we see the world and ourselves more clearly. The physical work of art is simply a byproduct of our understanding. Sometimes it helps others; sometimes only ourselves.

Theoretically, we can become disillusioned by what we learn as we get deeper into our work. Some—with the fantasy of being an as-yet-undiscovered artist—might prefer to cling to the false impression that art just happens effortlessly to a few people of inborn genius. To find out that painters work extraordinarily hard, that they are often solitary and unappreciated, may be hard to accept. We can only hope that confronting such realities does not dampen too many dreams of those striving to be artists.

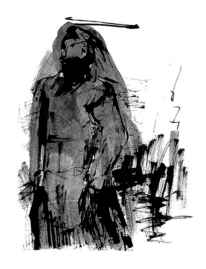

A p p r o a c h e s

Seeking a holy place within myself, the place where my art begins, has opened doors for me that were previously shut. The search has made my life more meaningful. Hard work and standing alone—me and my soul—are second nature to me now. Perhaps it is or can be for you, too. Here are some ways to look for your holy place.

PILGRIMAGE

Visit a place that you find holy. If it is not respectful or comfortable to paint on location there, work with that subject from memory when you get back home. But whether on location or at home, before you make any mark on your watercolor paper, first absorb that inspirational subject deep into yourself. How does it look? How does it sound? And smell? What does it feel like to touch those stone steps or wooden pews? Take in as much as you can, and carry those impressions away with you. Whether it's an ancient Grecian temple or a contemporary Japanese shrine, the search for your holy place is the same.

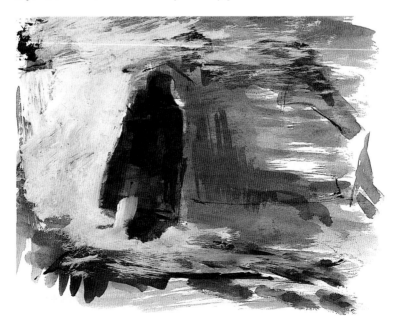

If your beliefs permit you to make images of events described in a holy book, that is an option to consider. Find a sacred text or object that commands a response in you. Monks were long inspired by religious texts, transforming them into illuminated manuscripts.

But of course, not all artists find a source of images in religious materials, and others have belief systems that preclude figurative illustration of biblical events. In those cases, artists may create beautiful work from letters, words, or phrases drawn from sacred books. Working within your conscience and your beliefs, find the images that are acceptable to you and express your interaction with text or objects.

INNER SEARCH

Concentrate on the holy place inside yourself. To do this is a creative task in and of itself. When you are ready, put your inner experience on paper. You may identify it as God, as love, or by some other word, but once you have even the tiniest grasp on the experience, paint it—even a word or a design—abstractly or figuratively.

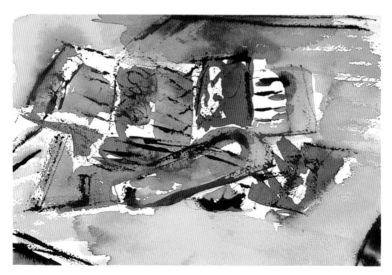

SUMMARY

What do you know of the holy place inside you? Can being in touch
with it help you find your subject, your medium, find out whether you
wish to paint at all? Will you find what you are looking for in a loca-
tion, in a set of beliefs, in meditation practices, in nature—in the faces
of other people or in landscape? We each discover it differently. If we
all looked in the same place and saw the same things, we would under-
estimate the wonderful variations among us.

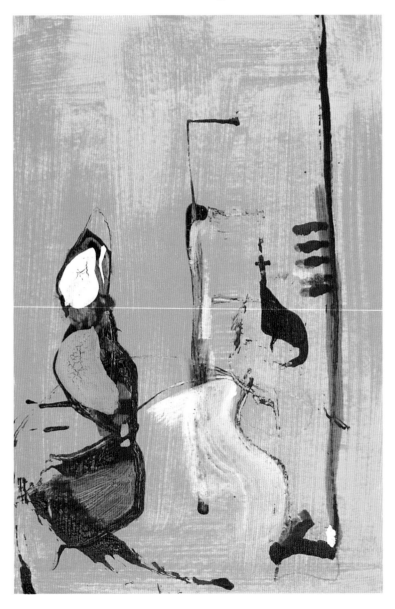

PUTTING IT ALL TOGETHER

Landscape

Landscape painting is Van Gogh—easel strapped down, secured against winds coming at him from every direction—intensely slathering paint on small canvases that he'll finish in one day. Or it is Georgia O'Keeffe, sitting in her specially outfitted car, painting her beloved surround with only the car roof between her and the scorching southwest desert sun. Or Claude Monet, in his personally created garden, catching the light, the ever-changing light.

Landscape painting is all of these, and at the same time, none of these for me. I approach landscape with watercolors and paper, not oil paint and canvas. The wind, sun, glare—and the darkness as sun sets on my subject—affect watercolor differently from oils. Water evaporates quickly in wind and sun. Puddles of color pushed by air currents shift the pigment pool, and that changes the form I am painting. Evening dew slows drying and stretches my patience. I am tired; I want to go home. I would leave immediately, but I must wait. I have learned that shapes are intimately linked to how a pool of paint dries. They, not I, set the pace.

The animals were there before I was; I am a guest. To observe them, I stay in one spot rather than chase after them. I see bird-watchers or butterfly-searchers walk briskly to spot their finds. What would happen if they just sat still in one place and waited for local animals to come to them? I do, and when I sit in Central Park, animals come very close by. Squirrels try to drink from my water supplies, so I keep my jar of fresh water farthest from me while the pigmented water is by my side. Before I learned that, I would reach over to remove the rinse water from their reach. That sent them scurrying away, but they would come back again.

Bees seek color and hover around my palette. People are conditioned to fear bees and their stings, but for some inexplicable reason, I am confident that a bee would never harm me. So far, one never has. However, wasps and mosquitoes do attack me, so I shoo them away before they get too near.

Sometimes I feel as if I am in a fantasy land with birds and squirrels walking around my feet—an urban peaceable kingdom. The animals seem to accept me as one of them, rather than as a predator. They just go about their business as if I were not there. But when I paint them, they are never still. Nothing in nature stays still very long. When I paint a human model who holds a pose for long minutes at a time, I'm able to

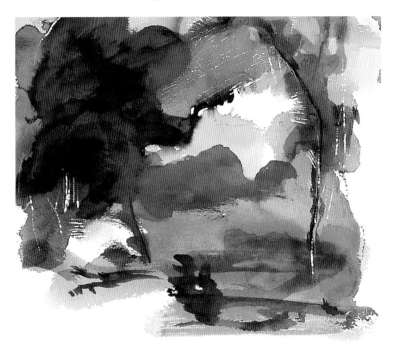

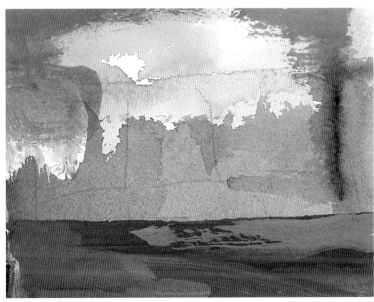

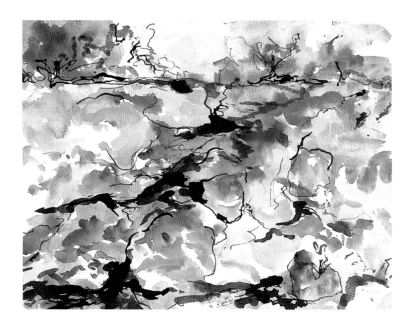

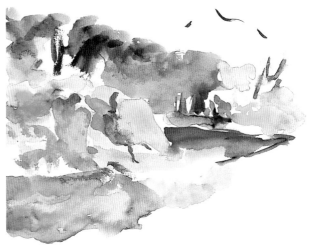

work at a slower pace. But with landscape, something is always happening. Wind sways the branches and the leaves on the branches—so much for position; sunlight goes under a cloud and then out again—so much for shading. A bee is busy at the flowering tree that I've made the focal point of my watercolor painting. Its presence distracts me from painting the blossoms.

Not only a bee can make me lose my focus; a city landscape is a minefield of distractions. A person, an insect, a bird, whatever I see, finds its way into my paintings. It turns my attention from the trees—seemingly there forever, yet constantly moving. Their sheer size, persistence, and

beauty gradually win my attention. I sense their deep roots, their stability, their silent contribution to life on our planet—which could not exist without them. Trees seem rigid, but they are not; they move with the wind, but also slowly and insistently toward the light or away from it, toward each other or away from each other. Each develops an individual form. I can recognize only a few trees as individuals, but I'm getting better at it. Imagine naming trees, not just according to species but "John" or "Sue" or gender-neutral names.

Often I only sketch in the park, then turn my drawings into paintings back at my studio. I've found that if I complete a watercolor on location, I'm not as inclined to develop that composition into another painting. It's as if that picture is finished, so why do another one that would lack the power of my first reaction on site? So if I have a sketch

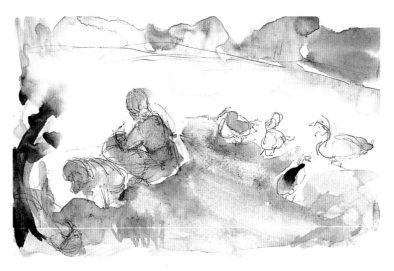

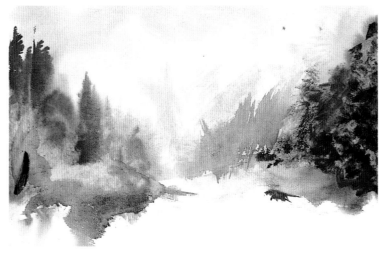

in pencil, ink, wash, or even in watercolor—not a finished work—there may emerge many painting alternatives back in my studio. Sometimes I've created tens—even hundreds—of pictures from one strong idea.

At some point, I established two kinds of outdoor working sessions. One is to gather ideas, to sketch for paintings I'll create later. On other outings, I take along high-quality paper and do very few works, sometimes only one. I concentrate on completing that painting outdoors, readying it for framing back at the studio.

Comparing my outdoors work with my studio work, which was stronger? It varied. A good piece done on location was as strong as one created in the studio—but they were different. In the studio, I could work out my composition and develop the washes slowly with more controlled drying conditions. But when a work was off, it had a detached quality that I found unappealing. Work done on location was never emotionally detached, but it could lack the level of structure I had come to value in painting—and even come to see as the heart of a landscape painting.

Some artists imagine the vistas they paint. In an earlier chapter, I wrote about Gainsborough and his "kitchen" landscapes. He had nature in his head. As he arranged pieces of coal and broccoli on a table to simulate landscape forms for a painting, he saw in them the shapes of rocks and forests, bushes and trees. As viewers of his work, we can readily envision the place he painted and easily believe that such a scene actually exists, that Gainsborough saw it as he painted it. He did, in his mind's eye, and we do in ours.

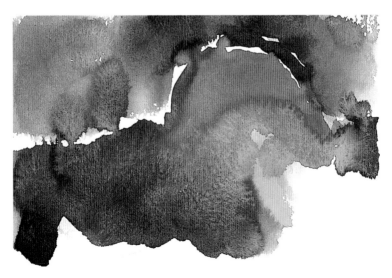

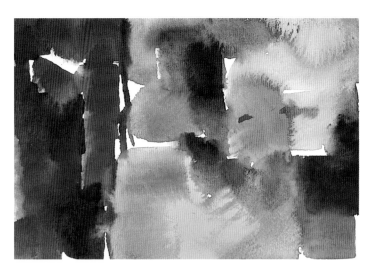

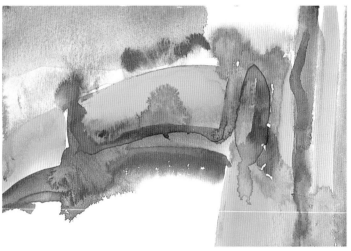

Even without broccoli, it's possible to imagine landscapes, to make up beautiful places—also scary places. One evening, I was lost in the Tivoli gardens in Copenhagen and could not find my way out. Booth vendors beckoned me to play their games, to see their entertainment and displays. The bright flashing lights and loud, repetitive music punctuating the darkness felt like a trap. In actuality, it wasn't; the whole garden is only a few blocks square, and there is no way of really getting lost in it. But for a few minutes, it was a miniature house of horrors for me until I reached the quiet of the inner court. Then I realized that if I, an adult, was frightened, how might a child feel? Could someone enjoy being scared in such an ostensibly safe situation—and use that experience for a painting?

Other inspiration comes from landscapes that are peaceful and
serene. Once, as part of a conference I attended, each of us in the group
was asked to visualize an image of a landscape, a safe and beautiful
place. I was uncomfortable sitting there with closed eyes in a room
with strangers, allowing myself to let go enough to conjure up a scene,
no matter how calm or peaceful it would be. I opened my eyes a few
times, but then got into the task and relaxed. Soon I felt calm imagin-
ing a scene. Once the landscape had taken shape in my imagination and
the conference was over, I might be able to revisit that scene—bring
the image into my consciousness at will.

After the exercise, we compared landscapes. The images each of us formed were vastly different from one another. One was of the seashore, another of mountains, some in a crowded city, others in suburbs, others in isolated country settings. What each person found soothing and safe was individual. Our "safe" places could not be traded, going from woods to seashore, just like that. Our choices, coming from deep within, weren't completely in our control. Are there limits to the kinds of images we can make that are unconnected to our skill or training? Do they relate instead to who we are as people—whom we have become over the years?

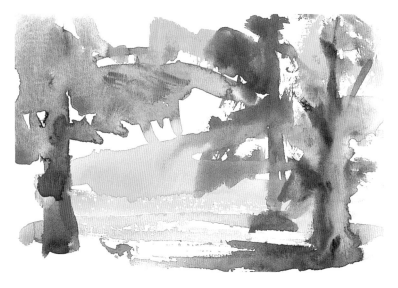

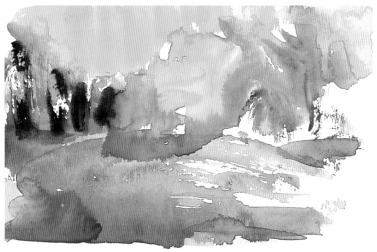

A p p r o a c h e s

One advantage to painting landscape is that you may choose restful places to bring your personal thoughts to on difficult days. Do you focus on the mood of landscapes or do you look at them as works of art and think about color, composition, line?

PAINTING ON LOCATION

Go out and find a landscape that pleases you. You'll soon discover that not every view is a landscape subject for you. For some people, trees will be essential. For others, it is a treeless plain or tundra that epitomizes landscape. Whichever of the infinite possibilities you prefer, paint it outdoors—but protect yourself as much as possible. I take suntan lotion, a hat, appropriate glasses, and anything else I need to help me concentrate on my work and not on extraneous matters.

As a woman going out to paint in an urban environment, to feel safe, I like to have some, but not many, people in view where I am working. Then I don't worry about my purse being stolen while I contemplate whether to use this shade of yellow on the sky or that slightly redder one. I can paint with people watching, but some artists feel bothered by onlookers. Watch your feelings and see what interrupts your painting process.

Imagine a landscape, particularly one that is pleasing to you, a place where you feel safe and can return to in your mind's eye. The first time I imagined a scene, it was green with rolling hills and trees. I saw the sky a particular way, and I painted that. Years later, when walking in a state park, I turned around to speak to my companion, and there it was! I saw that scene before me—but I had no conscious memory of having been there before. Then I realized that during the first year of my life, my family had spent the summer in that town. Perhaps I was in that state park then. I don't know. I certainly had not been back since infancy.

Once you start using images from your inner life, it is always possible that you may find out more than you bargained for in the process—just as I did when I saw in real life what I thought existed "only" in my imagination.

SUMMARY: LIFELONG SEARCH

More than once in my life, I have changed my focus in painting. Instead of working solely from imagination, I paint from life, or I draw from life and then make paintings in my studio. Flux, change, a lifelong search is part of painting. It has become a little easier to let go and begin again— to trust that each approach is powerful and right for a different period of my life.

I have come to trust that there is a level of organization of my mind outside of consciousness. I enter that realm with caution and trepidation, but I do enter it. Each time, the order and comprehensive nature of the resulting images or thoughts surprises me.

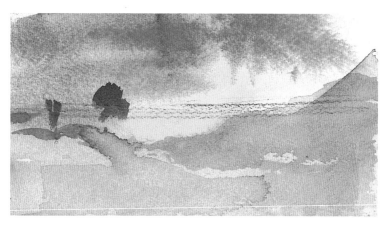

Walking

on Freshly

Fallen

Snow

YOU'VE FOUND YOUR PATH

What Now?

At a recent show, someone pointed to my self-portrait on the wall and asked me, "What is it about?" I described the structure of my painting—the grids I create by letting the paint drip down the paper or canvas. I explained about my having given away my oil paints because I disliked their viscosity—how I hungered for a fluid medium like watercolor.

As I spoke, I could see my questioner becoming bored. Being polite, she didn't tell me that she wasn't interested in what I was saying, but I knew I had lost her. I believed in my work, but how could I claim her attention so she could better understand it?

By the time I got home, I had figured it out! I had not told her the whole truth, only a part of it, because until that moment, I had not been aware of the rest. I paint from my subconscious and rely heavily on it, even when I paint from nature. But what do I say when I do not consciously know my subconscious meaning yet? I may never consciously know what I am painting. And what do I say if the revelation seems too personal?

Here is what I did not say because I did not know it yet: The self-portrait in the gallery, "Who I Am," is a product of my subconscious as well as a view in a mirror. It is a picture of myself as artist-wolf. Some people asked, "Is it a picture of a wolf or of a person?" It is both. But I was unaware of that duality when I painted the picture, and later, I was afraid to say it.

Because I was first unaware and then afraid to talk about the work as I had come to see it, I could not verbalize my ideas effectively, and I lost that first questioner. I was not scared to make and show an image that pleased me. But I was frightened to tell that woman about it—worried she would not understand, and I would seem silly and not nice. What would I have had to say about how I discovered that it was the picture of a wolf—as well as a self-portrait?

I had framed the piece; it was all bubble-wrapped at my home, ready to be delivered to the curator. It happened to be upside down, and I noticed that it looked like a wolf. *Funny,* I thought, *upside-down it looks like a wolf.* I had read the marks like an ink-blot, smiled, and said to myself, *What the mind will do.* Then, out of the blue, my husband said, "That looks like a wolf." It was not just I who saw it. The double image was out there—one other person had seen it—and then, people at the show saw it, too.

What they did not know—and what I had never thought of until that moment when the finished painting was framed and wrapped—was that I had had a photo of a wolf up in my studio for over a year. I had never painted or drawn from that picture. Nor do I know where I had found the photo or why I put it up. All I know is that a wolf unconsciously appeared in my work.

Was it just an accident? Who knows. One instance could be an accident. But two? Because I realized next that behind the wolf in the photo—which I had never worked from consciously—was a birch tree. In an entirely different set of paintings, I had spent the past year drawing two trees. One was a birch tree. Both wolf and birch tree were in the same photo.

There are many photos, found objects, loved rocks, dried flowers, all kinds of things in my studio. What led me to chose the wolf-tree photo in the first place and then leave it up, although I had disposed of others in hours or days after acquiring them? These objects keep me company in my studio. I like having them around, but am not aware of even

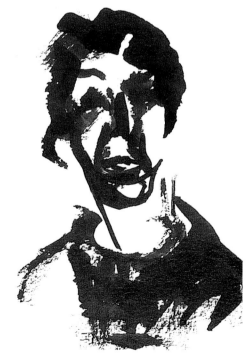

looking at them very much. Do they influence my work? Maybe I picked one of so many available photos of a wolf with birch tree because those images were already rooted in my subconscious? I think so.

My wolf is not a scary werewolf. It is scary in a different way, but wonderful at the same time. What *is* scary is seeing the wolf in me. The only one threatened by it is me. This is the artist as wolf. The same wolf Gauguin talked about in a fable that generally goes like this: A well-fed dog meets a half-starved wolf and tells him that if he comes home with him, people will feed him and look after him. The wolf is tempted and goes along. He is hungry. Once they reach the front door, he notices something around the dog's neck and asks what it is. "Oh, it's just my collar, they put a collar on me." The story says the wolf bolted into the woods and starved to death rather than wear a collar—rather than lose his freedom.

The artist-wolf is not collared; the artist-wolf stands apart and alone. The artist-wolf bears the consequences of that position.

I am not sure that being an artist means being alone, literally or emotionally. But I am sure that an artist must have the courage to stand alone, not just in making the work, but in telling others about it. Is it easier to talk about other people than about ourselves? About positive emotions and experiences rather than painful ones?

If you have something to say about your work that scares you, I hope you have more courage than I had at that moment in the gallery. By not standing up for your work, you risk short-changing yourself, and you deny others the opportunity to understand your paintings.

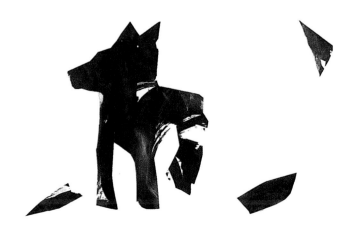

Getting Lost Again

Getting Back Again

I prefer to be in the middle of a body of work, rather than to be at the end or even at the beginning of one. The beginning may be the most exciting time in the development cycle, but it is fraught with anxiety and doubt. The middle, for me, is pure joy in the working through of an idea, and the end of a cycle is sad and frightening at the same time. I am sad that it is over and frightened that I may never find another cycle. Will my passion for painting die?

Once I believed that it never could die. Then many years after college, I met a former professor. He asked what I was doing. After I told him, I naively said, "Of course, you are still teaching poetry, and you still love it." He had been a great teacher. His surprising reply stayed with me. "You cannot take that for granted," he said. "Yes, I am still teaching, and, yes, I do still love it. But my relationship to poetry is like any other relationship. It could end, unexpectedly. I might gradually lose interest, or just wake up one day and know it is over. Then, there is nothing to do but find another passion." Since that moment, I cannot bring myself to say I will paint in watercolor forever. I paint now.

It has been difficult to trust in my subconscious and follow its lead. I like to know where I am going. But I have learned to trust my subconscious, some might say my soul, just as I have come to trust the watercolor medium. I must follow them, not blindly—since I can always stop painting. But I cannot paint just any old way, on a whim.

In the past, I would wait until I had exhausted one painting idea before looking for another. Since then, I see my work as always being in the beginning, and at the same time, in the middle and at the end. I consciously plan my work this way. I am writing this book. That is now. I am consciously planning my next project in spare moments on the train or when resting at the end of the day. But I also trust that, completely hidden from me deep in my subconscious, there is another thread forming that will gradually come forward. I cannot force or push it along, but I can allow myself to be open to new experiences.

For example, I am taking piano lessons again after years of being away from playing. There is no practical reason for this, and I have no clue as to

where it might take me in my art, let alone in my life. But now I permit myself "digressions" more easily than in the past, because they have led me and my art to new places. Relatives and friends used to say, "That's a waste of your time." I fought them, and they have stopped saying it. They have seen that what I do will gradually lead somewhere. Besides, no matter what they say, I will do it anyway. We have an amicable truce.

I still have to fight to explore new territory—to fight the more conservative, security-seeking parts of myself, and others who are genuinely concerned for my well-being and do not want me to give up time from the good things I have done in the past. But I can only live with a frontier, a new one on the horizon all the time. Otherwise, I feel stuck, emotionally numb, a little bit dead. Life has less meaning when I have no frontier. When I recognize that numbness in its earliest stages, I permit myself to live it as a step in the formation of my next frontier.

My husband is right; he did marry a process. He values the life I lead and helps me when he can. I change, and that is hard on both of us, but he is never bored, has never had to worry about entertaining me. He is free to build his life and to enjoy some of the perks that have come from mine.

Not everyone wants what I want from life. Even I would not necessarily choose this restless state if I had a total say about how to live my life. But I do not. Whether it is in my nature from conception or has been environmentally instilled in me, this is the way I am.

I have shared with you how I learned more about who I am as an artist, not so you will paint the way I do, but so that you may see one process at work—see what aspects of my experience might clarify your own search as an artist.

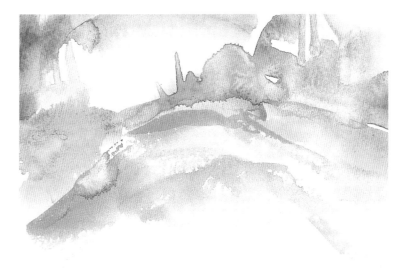

I N D E X